Windflower

Windflower

A NOVEL

NICK BANTOCK

AND EDOARDO PONTI

CHRONICLE BOOKS

SAN FRANCISCO

Library of Congress Cataloging-in-Publication Data:

Bantock, Nick.
Windflower : a novel / Nick Bantock and Edoardo Ponti.
p. cm.
ISBN-10: 0-8118-4352-1
ISBN-13: 978-0-8118-4352-2
1. Winds—Fiction. 2. Courtship—Fiction. 3. Young women—Fiction.
4. Self-realization—Fiction. I. Ponti, Edoardo, 1973- II. Title.
PR6052.A54W56 2006
823'.914—dc22

2005023591

Manufactured in China.

Designed by Jacqueline Verkley

Distributed in Canada by Raincoast Books
9050 Shaughnessy Street
Vancouver, British Columbia V6P 6E5

10 9 8 7 6 5 4 3 2 1

Chronicle Books LLC
85 Second Street
San Francisco, California 94105

www.chroniclebooks.com

With many thanks to Edoardo Ponti for his ideas and encouragement, to Joyce Greig who graciously helped me create the artwork, to Jacqueline Verkley whose sense of design is peerless, and to Annie Barrows, my wise and witty editor.

For Joyce

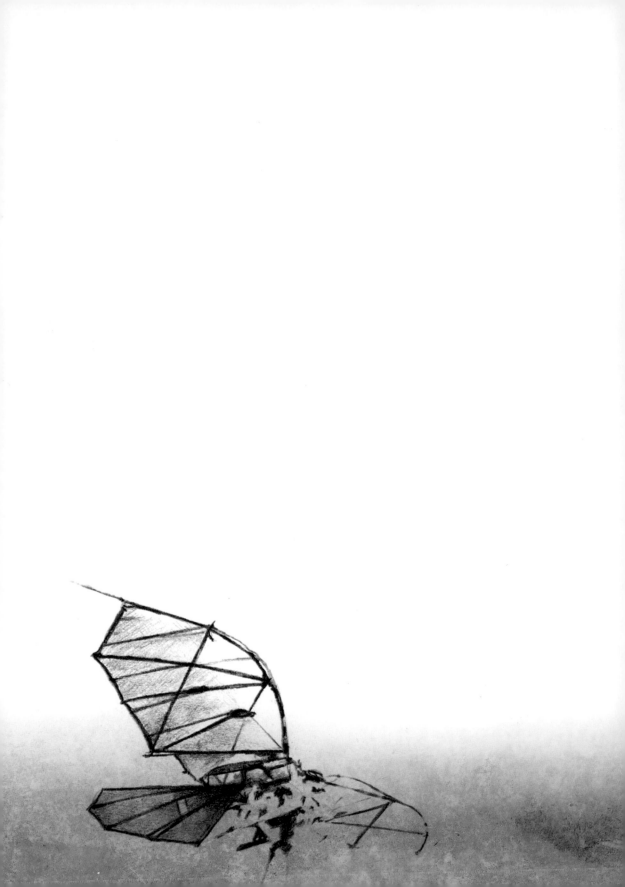

1

"Pox!"

"Pox!"

She wakes to the sound of her father calling the dog for its breakfast. Ten years ago, on her ninth birthday, Ana had been given a puppy—she'd named him Pax and her father had called the animal Pox ever since. Not because he disliked it, or because he wished to upset Ana, but because it satisfied a deep need within him. "Pox" was the insult that had been thrown at the Capolan people for half a millennium, and Talimus Dijjo wanted the right to bellow out the same slur that had pursued his kinsmen down the ages. When his young daughter first challenged him about the matter, he had pointed out that he couldn't possibly start the day by yelling for "peace." He abhorred the idea that anyone might think he'd gone soft. The girl, who loved and at times detested her gruff father, had no idea how to dissuade him from switching the vowel and destroying the dog's status within the campsite. Ana, however, had always addressed Pax by his real name, as did her grandfather, whom no one in their right mind would dare call soft.

Ana takes a last look around her tidy caravan and runs her fingertips over the small collection of books that fits snugly on her alcove shelf. The time has come to leave, but first Ana presses her face against the slats of the wooden shutter and looks to make certain that the moon has passed behind, and not in front of, the big hill. It's a ritual she's loath to break, a last bastion of youthful superstition within her adult world.

Tying her long black hair loosely at the nape, she steps out of her caravan into the morning. Turning her back on the gloomy vista of the junk-strewn camp-site, she begins to climb the crumbling earth that forms the hill's stairway. On any other day, her dancer's feet would carry her nimbly up the steep slope. Today she is meticulous, picking out each step with care, making certain that every-thing is done with a respectful precision. Her legs are heavy, as if the conflicting feelings and thoughts in her heart and mind were tied like rock-sacks to her ankles. She has a speech to deliver and she has little notion of how to begin.

"I've come to beg . . ."

No! *Beg* makes me sound like a weakling.

"I wish to petition . . ."

Can a petition be one person, or does it have to be a number of people?

"I've come to ask for . . . I've come to ask for . . ." What exactly is it I've come to ask for?

Help? Wisdom? Clarity?

The loitering goat who has been the recipient of these questions responds in standard vernacular.

Ana laughs, more to discharge her growing tension than anything else. She is furious with herself for having left her plea until the last day. "I know, I know. I should just get on with it. But if I don't do this properly, my life is going to be eternally miserable." The word *miserable* sticks in her throat and she has to hold back the urge to cry.

Glancing behind her, she sees the tiny caravans dotting the valley below. As always, they are placed in a pattern that mimics the bridge of stars between the Great Bear and Orion's Belt. She distracts herself from her emotion by wondering, for the umpteenth time, which of her forebears conceived this copying of the heavens. A glint of sunlight reflects next to one of the caravans. She smiles, guessing that it's bouncing up to her from her grandfather's shaving mirror. He's always first about the campsite, bending over the water bowl, scraping at his night-whiskers with his silver cutthroat razor. Taking the blinking light as a sign of encouragement from her grandfather, she straightens her line of sight and continues to climb. After ten minutes the old Windtower comes into view. It was built when the Capolan people first came to this part of the country, but now very few of her clan bother with the climb. What had once been a symbol of the tribe's allegiance to the winds has degenerated into a sun-bleached curiosity. Ana's breath becomes hard to find. She stops, forces a slow inhalation, and then proceeds.

If Ana were to stand seven times on her own shoulders she would not be able to reach the top of the tower. It's constructed from thick wooden beams that gradually narrow until they become fingers braided into a single fibrous

strand. Around the tower's center rotate four rounded chambers. North, south, east, and west are stacked, not side by side but one above another. The whole tower, resilient in its flexibility, sways back and forth at the winds' whim.

Ana walks around the tower and then kneels before it. Like most of her ancestors but few of her peers, she believes the winds take an active interest in humankind. Her people once looked upon the winds as deities, immortals who ruled the heavens and tended the earthly plain. Capolan legends speak of how the four wind gods, along with their sister Halcyon, would descend each winter to clear the pathways for the wandering tribes. Then, in the spring, they would return to spread the fresh seeds that gave roadside nourishment.

But even as she keeps faith with these ancient tales, Ana knows that winds have their own business to attend to and are not inclined to listen to the selfish ramblings of a young woman. Drawing a deep breath, she focuses on the painful struggle within, looks up beyond the tower, and imagines the forces swirling and gyrating high above her. She clears her throat but nothing comes out. She tries to speak but is mute. In desperation she fumbles in her skirt pocket and withdraws a flute. Pressing the pipe to her lips, its tiny melody releases her voice; she opens her mouth wide and the cracked words of a deepsong begin.

"In the caves of my heart, where pain taps out its rhythms and sorrow sets its loss, I am without direction."

Now that her throat is freed, Ana begins to relate her plight. "Today I am to be wed to Marco. I do not dislike Marco. He is not cruel or even harsh and for someone else I'm certain he will make a good husband. But it shouldn't be me."

Now that the words come, they pour forth in a torrent. "It's not that I'm arrogant. Well, maybe a little too proud. It's just that when they paired us I never really thought today would come. I do not love him, no. But more than that, I believe this will harm my people. Marco's parents own this valley, and if I marry him, our families will be joined and the tribe will have a homeland. My father wants this union and I do not want to oppose him. He is my father."

She bites down on her bottom lip. The memory of Talimus Dijjo's glowering face tries to threaten her resolve.

"And yet I believe that this is not the way of our people. We have always been travelers—not landowners. A torpor chokes us and if we stay here any longer we will shrivel and die." Ana looks up at the scurrying clouds. Do the winds really care? She ploughs on.

"Grandpa believes the old tales. You know the ones, about the dancer who heard the earth's cante and guided our ancestors across this continent. They say the dance used to be born anew into one of the tribe, but who has that gift now that we have grown weary and settled and the line of memory is broken? Ever since I was little, Grandpa has told me again and again that it could be me, that I could learn the dance and be the one to take our people to our next home."

Ana casts an imploring glance upward. "That won't happen if I marry Marco and stay in the valley. It might not happen anyway. But if there is a chance that he is right, then I must leave the campsite. Grandpa says I must go to Felix Bulerias, the only one who knows enough to teach me."

Ana watches the tower, hoping that the winds might give some indication that they have been listening. The chambers remain still. "How can I learn from Felix Bulerias a dance that cannot be taught? And yet, how can I close my door to the outside world and quietly sleep here when my people are deaf to the voice that once came from within us?"

There is a long silence.

She thanks the winds for their patience, gets to her feet, and turns as if to go. Then, in an afterthought, she continues. "I confess that that is not my only reason for being here. I want more from life. How can I give myself in marriage to one man while the zig-zag snake of desire inhabits my soul? It would not be fair to either of us.

"I have always paid attention to your directive. I have watched the signs and been guided. If I am truly meant to marry this man, show me that it is so. Please do not leave me torn between this valley and the pipe's call."

Stepping back from the tower, Ana takes the downward path; her heart begins to ache and she feels the tears swell in her eyes. She has no power to stop them.

Bathed in the new morning's sunlight the narrow valley is an Arcadian dream marred only by the weatherworn and shabby campsite. The early summer flowers and the last of the fruit blossoms add vibrancy and sap to the sages and ochers of the short and long grasses. Ana's kin have lived on this land since she was very small, and it is all she remembers. Apart from occasional visits to sur-

rounding villages, this valley has been her universe. The Capolan have been here for over thirty years, a long time for a vagabond people.

In the caravan that served as a school, Ana and her companions were taught her people's history. They learned how, more than six centuries earlier, the Capolan had come into being when a small band of wandering holy men had stumbled upon a group of stranded Lubekian farmgirls and forsaken their celibacy (the word celibacy caused much giggling amongst Ana's more precocious classmates). The expanded band had begun drifting from region to region, living in the vacuums created by the Plague that had wiped out two-thirds of the continent's population, never owning land yet always leaving the ground they borrowed better cared for than when they arrived. Good stewards though they were, they were frequently scorned and then driven away by those in surrounding districts who clung to an innate mistrust of anyone who did not live in a fixed dwelling. For all the hardship, the Capolan had steadily grown in number and their customs and honorable intent had kept the tribe united. War, changing climate, disease, and famine had over the centuries provided the Capolan with temporary homelands across the landmass from one seaboard to the other. But in recent years there had been fewer major catastrophes and humankind had flourished—open land had become scarcer.

What her teachers did not emphasize, but Ana worked out for herself, was that by the time she and her friends were born, the Capolan had become a splintered clan, fractured into small groups, slowly losing their spiritual memory, their self-respect, and their principles of tribal movement. Having once lived and danced to the magnetic compass within them, the Capolan had

become immobilized. Their subtle adaptability to change had deserted them, and stagnation threatened their individuality and their future.

When Ana arrives at her grandfather's caravan she hurriedly wipes her eyes so that he can see the girl he wishes.

"Ana. Good morning." Her grandfather is clambering down from the Polestar's roof, paintbrush in hand. "Isn't the yellow magnificent? I chose it specially for my favorite granddaughter." The curved wooden beams that horseshoe the structure are gleaming with new paint. Each summer, he gives color to his home—and as always the shades are both brilliant and *almost* harmonious.

Ana laughs. "I am touched that the handsomest caravan in the valley has been newly adorned in my honor."

Grandfather glances toward the bedraggled wagons strung out on either side of his. "We have not all lost our pride," he says disdainfully.

It dispirits both of them to think that theirs are the only wagons that boast a fresh coat of paint. But now he shakes his head as if to free himself from such thoughts and draws Ana into a gentle bear hug. "You know you don't have to go through with it—don't you? You don't have to bury yourself here like some root farmer." His words are laced with bitterness and his look is mournful. "If you are tied down you will never be able to lead us."

Ana hates to see sadness in the old man's face. "Grandpa, I do not know if I have it within me to find our tribe's lost path. You seem certain that Felix can

teach me, and I have faith in your judgment. Yet it is so hard to go against the wishes of my parents."

Since she was young, Papa Dijjo has educated her, listened kindly to all Ana's hopes and anxieties, and encouraged her to keep her freedom.

"You are the only one who can lead us from this graveyard." He gestures toward the disheveled encampment.

"But you are our leader, Grandfather. I am only a young woman."

Her grandfather huffs in disdain, "I *was* the leader, until I stupidly passed the reins to your father. I don't know what I was thinking. He calls the tune now, and his ears are plugged. It is you who were born to show us the way forward." He is gripping her arms, willing his belief into her. "Ana, you still have a choice."

"It is only you who believes that, Grandpa." She hugs his mountainous bulk again and whispers, "I've been to the tower. Maybe the winds will help us."

She sees her mother comb and braid the bride's hair. The bride has very dark brown eyes, a high-bridged nose, and a jaw that is a little wide at its hinge. Ana has been staring into the chipped oval glass for two hours and she has lost track of who she's looking at. Her mother is asking her a question and she is forced to resurface from the sanctuary of daydream. It comes as a shock to her that the girl in the mirror is herself.

She glances around the room to see if anything has changed. To see if the winds have sent some sign that will spark the epiphany she desires. The room is unaltered.

"Keep still. You're wriggling around like a jelly lizard," her mother scolds.

"I can't help it. Who can sit still when they're getting married to someone they barely know?"

"Ana, don't start that again. You've known Marco since you were both five. He's perfect for you. We've been waiting fourteen years for this day and we can't have you fretting about small details."

"I've only talked to him half a dozen times, and . . . " But Ana doesn't bother to finish her sentence because she understands only too well that the conversation is pointless. Her mother is deaf to anything other than the delightful inevitability of this coming marriage.

A few hundred yards away Ana's father and five other men are stacking thick dead branches onto the unlit bonfire. With a practical task before him, Talimus is in his element. He wishes all his responsibilities were this simple. The guests will be arriving soon and then he'll have to change into his best clothes and play another role, one he feels far less suited to. His own father, who as the family elder was supposed to speak for the bride, has refused to be part of this wedding, so the task has fallen to him. Talimus sees Marco in the distance and a wave of resentment passes through him. He is, he believes, wholeheartedly in favor of the young man's marriage to his daughter. Yet if he were able to peel away his emotions he would see that he is distressed by the idea of another man replacing him in his daughter's affections.

Talimus is not a heartless person. He understands that Ana, like his father, cannot forgive him for rejecting the nomadic traditions of the Capolan, but he

has to face the reality of a changing world and a tribe who no longer have the desire to drag themselves off on a journey with no clear goal.

Ana's preparations have progressed. She has been draped in three of the four layers of her wedding gown, the white, the black, and the purple. Her aunt has brought the fourth layer, a snake-scaled headdress of silver coins, from its hidden nest and will soon be pinning it to the hair that her mother has at last fussed into place. Well-wishers are coming and going, wanting to taste the wine and the excitement. Around her buzzes a world that seems to make no sense to Ana. The women laugh and giggle and sometimes have to shout in order to make themselves heard over the growing cacophony. No one notices the pain behind Ana's eyes.

Ana looks out through the window at the creamy clouds drifting overhead. They *have* to help me, she thinks. They have to show me how to do this or I swear I'll cast myself onto the fire.

Her mother and her aunt are fixing the cape to her shoulder. "And remember, Ana, this is a marvelous occasion for everyone, not just you."

The sun has completed its traverse across the sky. The great bonfire has been lit and Ana has been trussed and declared good enough to eat.

As Ana steps from the caravan, a fine mist begins to seep into the air and the coins on her headdress glister that much brighter from the braziers' light.

To the guests, she appears every inch the vagabond queen in her silver cap, embroidered tribal gown, and veil of lapis and lace. How can any of these

well-meaning friends and relatives know that if they are successful in sacrificing Ana to their dream of an idyllic union, the Capolan will ultimately lose far more than a daughter?

Ana takes her father's hand and starts the slow walk down the candlelit path that leads to the crackling fire and Marco. The flames flicker as a sharp draft blows through the trees. A few of the crowd shiver, but not Ana. She is sweating under the heavy woolen cape. She catches sight of her grandfather standing a little back from the throng. Does anyone else notice that the candle *he* holds is black? At least he has not forsaken her.

When Ana reaches her husband-to-be, Marco gives her a sheepish smile. She tries to smile back but fails. Instead, she nods in an attempt to reassure the boy. And in truth that's what he is to her, a boy. Someone who climbs trees and throws oranges down at her, someone who tries too hard to kiss her on the mouth at the Harvest Feast. How can she marry this boy who has never seen her dance, never heard the sound that passes through her when her feet are placed flat upon the ground?

Over five hundred people are gathered around the fire. Music has been coming from somewhere amongst the crowd. The talk and laughter slowly quell, giving way to a silent expectation.

Marco's mother begins the ceremony, extolling the virtues of her son. As she concludes her speech, the sky is lit by a short flash of distant lightning. Ana's father responds with his version of the young man's worthiness. Each sentence is acknowledged by the crowd's murmured agreement. The heavens mutter too, with a dark rumble. The two parents repeat their exaltations but

now it is Ana who reaps their praise. A few in the audience glance up to see how quickly the clouds are coming in. At last Ana's father says, "This woman, child of mine, I give . . ."

Ana feels as if her body will rip in half and fly off in opposite directions. Her jaw is clenched as if it will never open. In her mind she tries repeating the prescribed declaration of acceptance. She is being sucked closer to the point of no return. Thunder clatters around the hills, as if to announce a late and angry guest. The words from her father's mouth seem to be getting farther apart and the sparks from the fire are rising in slow motion.

Suddenly the storm breaks. From nowhere a violent wind hammers into the valley. An awning is ripped from its mooring and sent twisting into the treetops. Flaming branches are skimmed from the bonfire and borne off in the general direction of caravans. The rain clatters down like knitting needles.

The wedding party is thrown into instant mayhem—some run to secure the horses, others scurry for shelter. Marco tries to drag Ana from the watery blast but is knocked down by a well-aimed gust of wind. He tries to get up but is sent sprawling into a fast-filling ditch. In the midst of the chaos, Ana stands stock-still. Only her grandfather's eyes are upon her. He smiles and nods his approval.

The winds have taken her plea seriously. Finally, their intent for her becomes clear. If the Capolan are to break free from inertia, then it is she who must make the first move.

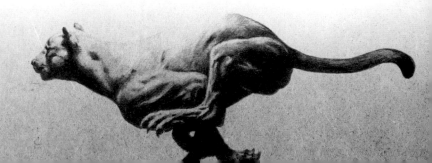

2

I ran as if the Demon King were chasing me. I dared not slow for fear that I would be sucked back to the valley. My eyes strained to make out the forest's night-shrouded path. I had no thought of the consequences of my wild flight until the burning in my lungs became too much to bear. I slowed to a walk, and only then did the reality of my actions sink in.

Was I crazy? Going against everything my parents wanted me to do and be? I stopped. I needed to organize my thoughts.

Why have you done this, Ana?

You know why—because I have to try and find Felix Bulerias and show Grandpa I am worthy of the trust he places in me.

What about your marriage?

Marriage? From what I've seen it's a bear trap. Look at my parents. They hardly speak to one another. If I ever get married it will be to someone who really knows me and wants the same things that I do.

You're so selfish. You don't care about all those people back there.

That's not true. I care about them more than anyone can imagine. I'm going to find a way to help.

How is a young woman who knows so little of the world going to do that?

I'll find out. I'll experience life and grow strong. I'll learn the dance, and my feet will speak and remind our people of everything that has been forgotten.

Do you really believe you can decide the Capolan future?

That's not what I said. And anyway I wasn't the only one who brought me here! The winds pushed me into the forest.

The storm had blown itself out and the forest had grown exceptionally quiet. I listened to the nothingness. No creaking of wagon wheels. No cats calling for a mate. Not even the reassuring snorts of the horses. In the pitch black the silence stretched on and on and a weighty tiredness crept over me—I could decide what to do in the morning. I cast around for a makeshift bed, felt a patch of leaf moss, crawled into it, and was asleep before I could fully curl up.

When I opened my eyes, the sun was forcing itself through the upper branches of the silver ash and oak trees that surrounded me. I sat up abruptly and rubbed earth mold from my face. How far had I traveled the previous night? Six, maybe seven miles?

Hungry and thirsty, I hunted around for sustenance. Of course, I'd been in the forest before; as children we'd played at its edges constantly. Never had I traveled so far into its heart. But the trees and bushes were of the same varieties and I knew what to look for. Grandfather had insisted on teaching me the nomadic rules of survival, and I was thankful now that he had persevered, despite the mockery of my father and his friends. I raided a squirrel's nest for

nuts, deprived some bees of a honeycomb, and sucked a number of large wild gooseberries through my teeth for their liquid. I felt quite proud of my woodland skills.

I thought of home, of everyone clearing up after the chaos. They'd be searching for me. I was fairly sure no one but Grandpa had noticed me enter the forest—and I knew he would say nothing. Would Pax be able to pick up my trail? I hoped not. I had to move on. I couldn't let anyone catch me. I was frightened to go forward, but I was even more frightened of going back. I stuck out my chin and followed it farther into the forest. If I walked hard, I could probably be out from under the trees before sunset.

At first, I was concerned about losing my way, but I remembered what I'd been taught about watching the angle of the shadows and I was able to keep a firm sense of direction. The diffuse light and the soft morning breeze warmed my face and even the fast-returning hollow in my belly lent a strange quality of expectation. It struck me that I had never gone hungry, nor had I been seriously mistreated. In fact, I had been fed and cared for for nineteen years. Perhaps that was another reason for my leaving? Grandpa always insisted that "Light is light only against dark." I needed to be able to measure my life against something different.

The day grew warm and I took off my cloak, rolled my lace and silver cap inside it, and tucked the bundle under my arm. As I walked, I sang, keeping my voice in a high register, marrying it to the song of the small birds that I could hear but not see. Although I had a fairly wide vocal range I rarely felt comfortable summoning the lower tones from my throat.

My argument with my conscience started up again and continued on and off for much of the day, guilt and responsibility trying to wear down my faith in whatever I imagined to be my future. I wished I had my flute. It would have been comforting to play it.

From time to time I'd catch sight of a small animal darting away at the sound of my footfall. Then I came upon a long-haired gray boar who seemed to consider the path his property. Carefully I scooped up some groundnuts and I was able to distract him with lunch long enough to allow me to pass by his menacing tusks. After that I thought about making a bow, but I discarded the idea, knowing it would be almost impossible to construct an effective arrow without the proper tools.

My march through the forest continued without further incident until mid-afternoon when I noticed what appeared to be the silhouette of a very large crumpled dragonfly wedged into the top of a massive oak. I was curious to know what it was, but the gnawing sensation behind my belt buckle was telling me to keep moving. Then I saw something glinting among the leaves about thirty feet from the ground. I hadn't climbed a tree for years, but that didn't seem a problem until I was about halfway toward my goal. I strained to see if I could establish what it was I was risking my life for. But I could make out even less than when I was on the ground. "Why is it that looking down seems so much higher than looking up?" I muttered, hauling myself onto the next branch. I pushed my head past a bunch of acorns and found what I had been searching for—a watch dangling by its chain from a thick clump of leaves. I unsnagged it and slipped it into my pocket.

I ignored a foolish impulse to keep climbing up toward the dragonfly and prudently started back down.

Delighted to be back on the firm forest floor, I took out the watch and examined it. It was beautifully made, with a bronze casing and a black face, but it had stopped and there was no winder. It only had one hand, and I had no way of knowing whether it was the minute or the hour hand that was missing. Then again, maybe it was not a watch at all. Maybe it only had a single hand.

I broke free of the tree line just as the sun touched the horizon. The forest ended atop a steep slope that afforded me a view across the countryside. Spread before me as far as I could see lay flatlands of mottled rye, maize, and heather. A serpentine river wove from one side of my vision to the other. I shielded my eyes and searched for habitation. Half a dozen windmills and a few small cottages peppered the landscape. About two miles away a larger L-shaped building nestled in the crook of the river. As I set out toward the structure, I just caught sight of a slim figure entering a field five or six hundred paces ahead of me. When I reached the field, I noticed that someone had made a fresh path through the short maize.

Ten minutes later I was able to confirm my good fortune: a pink-and-blue sign hanging above the front door of the L-shaped building declared it to be The Whistling Pig.

The inn was almost empty and the few folk who were already seated only had eyes for their glasses. I chose a small table in the corner of the room and waited to be served. I asked for a beer and some food, trying to sound as if it were something I did every day. The landlord looked at my rumpled clothing

and held out his hand. I reached for my purse, but where it normally hung there was nothing, not even a clasp. Panic rushed through me. Why hadn't I run away earlier—before I changed into my wedding gown? Then I remembered my dowry and reached for my headdress, but my head was bare. The landlord was standing over me, hands on his hips, a sneer at the corner of his mouth. But the bundle was sitting in my lap and I sighed in relief. I slid my hand into the folds of cloth, gripped a coin, twisted sharply, and pulled it free from the cap. I passed it to the landlord, who looked at it suspiciously. He checked it with his incisors and then asked me if I always drilled holes in my money.

"It's our custom," I said sweetly.

He grunted and moved away. A short while later a pretty little girl brought a plate of gammon and potatoes and tankard of beer. Her tray also held my change, a small pile of copper and brass. I gave the child a half reis and she ran off beaming from ear to ear.

When I'd finished every scrap on my plate and drained the last drop in my mug, I asked if there was a room available for the night.

I was so tired I thought I would sleep as well as I had the previous night, but instead one vivid dream after another whipped me like a spinning top. In the morning I awoke with my muscles tight and strained. I considered resting longer but I wanted to catch the first riverboat headed toward Serona, so I arose and washed myself from head to toe with cool water. Something in my dreams must have jogged my memory of the stranger I'd seen the previous day disappearing into the field of maize, because I started to wonder what had happened to him.

After an adequate breakfast of mixed fresh and dried fruit I sat on the jetty waiting for the riverboat. I had been told it would stop only if I flagged it down. So once the boat was within hailing distance, I called it to me. Watching as it changed direction and veered toward the bank, I felt like one of the Sirens summoning sailors to their doom on the rocks. Not that I meant anyone harm; I just found it reassuring that I held sway over something outside the campsite.

There must have been about thirty or forty passengers on deck, mostly people from the country dressed in their working clothes and carrying with them their tools of trade. I, however, was in my wedding dress—not that anyone would have been able to tell, because before breakfast I'd stripped it of any decoration. Even so, I was worried that I looked out of place. That feeling of not belonging is ever present in all of us Capolan.

Once I'd convinced myself that I wasn't going to be pointed out as a vagabond runaway, I relaxed and watched the shoreline drift by. When I returned my gaze to the boat, I saw a young man who looked a bit like Marco leaning on the rail and I was stabbed by a pang of guilt. I hadn't really thought about him since I had taken to the forest. How had he been feeling? Was he angry with me? I didn't want him to be in pain—I was just glad I wasn't tied to him for life. And, in truth, there was more than one young woman who would jump to fill my place. My younger sister, Jennene, for one, was always telling me how fortunate I was to be betrothed to Marco. I'd seen the way her eyes followed him. Now that I was gone, I was sure she'd gladly grasp the opportunity to console him.

Of course, my parents would disown me—*if* they knew I was alive. Grandfather would guess what had happened and he'd tell everyone that I had left for the sake of the tribe and that my mission was noble. I had made a mess, but at least I had one loving ally.

The boat docked around noon and I disembarked in a state of intense excitement. I stood in awe of my own actions. I had wanted to come to Serona since I was tiny, and there I was! It may sound odd, but I had no plan, no idea of what I was going to do. My hopes had been constructed of mist, but now they had become real, and I was floating in a living dream. Not having a map, I simply plunged into the maze of streets and avenues. I was engulfed by shops, houses, signs, postboxes, dolphin-shaped street lamps, and people, everywhere people. My legs felt wobbly, and then I realized it was because I was unused to the stone pavement; the flat stone surface beneath me was slightly unnerving. The few villages I'd been in had cobbled roads. Serona was so very different; it was as if the city itself had a pulse. It felt—eternal. The buildings didn't quite "strive toward the heavens like twisted sunflowers" in the manner I'd been led to believe, but they were impressive nonetheless. I had once been given a book about Serona and I'd read it until the cover had fallen away from the pages.

". . . In over a thousand years the architecture has incorporated all the styles of the millennium, molding them together in a remarkably satisfying manner." As I looked about me I could not disagree. "Built next to the ocean," it reported, "Serona was accessible to the rest of the world, though it lacked the flow of races that had once passed through it."

To my relief no one seemed to take much notice of me. They were all far too busy going about their daily chores to bother with an ordinary girl.

The afternoon sun was unusually hot, and as I had no hat (that I could wear) and the remaining layers of cloth that had kept me warm in the forest now threatened to roast me, I stayed within the shade. I was like a cat in a new caravan. Staring at everything; going into corners; trying to take it all in. Eventually, I had to pause and consider what to do. I wanted to save my dowry for later, when I really needed it. Earning some money was going to be essential.

I looked through windows and watched people passing by, trying to imagine myself doing what they did. I saw a notice in a bakery saying they needed an assistant. But when I went in to inquire, they told me they had already hired someone but had forgotten to take the sign down. I tried to think what accomplishments I had, but my camp skills weren't going to get me a job in the city. For the next two hours I went from shop to shop, asking if they needed help. No one wanted me. A few of the store owners were kind and were sorry they couldn't offer me anything, some were indifferent, and a couple of them treated me like I smelled of rotten fish. The last one mumbled, "Poxy vagabonds," as I left. I fired him a black look to show I had heard his insult. Anger faded and worry began. What if I couldn't find work? What if I had to go back home with my tail between my legs? I sat down on a small stone step and put my head in my hands, closed my eyes, and tried to think.

After a while, someone tapped my shoulder. Opening my eyes, I saw a red-haired woman holding out a glass of amber liquid.

"You look thirsty," she said.

"Thank you. I am." I drank the iced tea in three gulps.

The woman inquired if I was all right. I said I was, and I added that I'd be even better if I could find work.

"What kind of work?"

"Almost anything," I said, shrugging despondently. "I just arrived in the city and I need to earn my keep."

"*This* place could do with another waitress," she said, flicking her head to indicate the building behind.

I looked past her shoulder and saw the broad arched doorway with a sign above it declaring The Carta Rosa.

"In seriousness?" I said.

"As I stand here," she responded with a grin.

I thanked her and headed into the restaurant. A minute later I was standing in the office of the expressionless manager who introduced himself as Junto. He was neither friendly nor curt. He asked me if I'd waitressed before and, being honest, I replied that I had waited at my father's table but never in a restaurant. He told me to follow him into the kitchen. This I did. As soon as we passed the swinging door he reached for a plate that was sitting on the counter and without uttering a word tossed it over his shoulder. I was three paces behind but I managed to catch it, about nine inches from the floor. Junto turned and, without smiling, said, "Your first shift begins at five. We supply your uniform. Ask for Halle. She'll get you fitted and show you the ropes. Don't disappoint me." And without further ado he left the kitchen. I put the

plate back on the counter and returned to the street. The whole exercise had taken less than five minutes.

The red-headed woman who'd given me the drink was still outside. She was leaning against a pillar smoking a small cigar. I told her I'd got the job and thanked her again profusely.

"If there's any other way I can be of service," she said, in a way that was both affable and gently teasing.

"I don't suppose you know of any inexpensive lodging houses, do you?"

She considered for a second or two and then said, "See that street opposite? That's Caldero. Go up there, and then turn left when you come to Heradas. About halfway down, on the right, you'll see a narrow house with blue and orange wind shutters. Madame Terantartini is a sight and three quarters, but she's fair. She usually has a spare room or two. You might be in luck. I just took on another lodger, or you could have had one of my rooms."

"You have been very kind," I said. "Thank you."

"What's your name?" she asked.

I told her.

"Well, Ana, I'll no doubt be seeing you again," she said, giving me a wink.

On the way up Caldero, I passed a stall selling combs, brushes, and hair dyes. I ran my hand through my hair and felt the tangles. The boat ride must have been breezier than I'd realized. I still had change from my first silver coin and I used it to buy soap, nut oil, and a hairbrush.

With just over two hours until I was due back at the restaurant, there was no time to dawdle. Madame Terantartini's was only a three-minute walk from

the restaurant and I found the house fairly easily. It was old, but not too run down, and hanging from the door was a vacancy sign. I knocked and was instantly confronted by a voluminous and gaudily dressed figure who seemed to know what I was going to ask. "Yes, dearie, we have a room. Come in! Come in!"

I followed her into the hallway and up two flights of stairs. I said that I didn't know how many nights I'd be staying.

"That's fine. The new ones never do." I was shown to a room at the top of the house. It was reasonably well kept and fairly light, if not exactly cozy.

Tentatively, I asked the cost of lodging and was relieved to hear that it was relatively cheap. Seeing my relief, Madame Terantartini snickered, "It's all right, dearie, you'll be just fine here. I looks after my charges."

Whether she meant her fees or her tenants, I didn't ask.

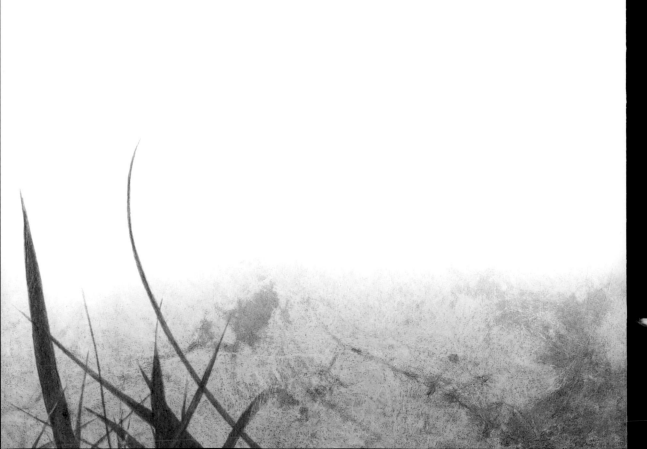

3

Nervous though she was, it dawned on Ana as she reentered the restaurant that she hadn't taken in the extraordinary physical appearance of the place. It was large and airy and felt like an outside courtyard housed indoors. Its floor was composed of broken tiles, not quite small enough to be called mosaic. This clay with its smoky patina had been cracked and broken by the hard-heeled shoes that had pounded it for over one hundred fifty years. To those at ground level, the floor's design appeared to be little more than a pleasant confusion of muted reds and blues. But the pigeons that sat on the wooden rafters looked down on the pattern of a giant compass-rose. Within the courtyard's circum-ference the white-clothed tables were scattered hither and thither, leaving the waitresses and patrons no predetermined paths to attend and be attended to. Each table was armed with its own canopy, first to protect it from the sun that at midday burned though the vaulted glass ceiling, and second to shield the customers and their meals from the uncannily accurate target practice of the aforementioned pigeons.

Ana did as she had been bid and asked for Halle. Halle turned out to be the red-headed woman who'd encouraged her to apply for the job.

"Looks like you've been put under my wing," she said with a welcoming smile. "Don't worry—this is a friendly enough establishment. Most of the girls are easygoing. There's the odd one like Gissel—the one with the pointy chin who just came out of the kitchen—whom you wouldn't want to cross. But she keeps herself to herself and gets on with the job. By the way, how did it go with Madame Terantartini?"

"It went well, thank you. She let me the room at the top of the house."

"I'm glad to hear it," said Halle, taking Ana by the arm. "Now, let's visit the storeroom and get you dressed for the part."

While she helped Ana find a uniform that fit, she described her basic responsibilities and how best to fulfill them. "Taking orders and serving food is the easy part. You know how a restaurant works." Ana didn't want to tell Halle she'd never been in a proper restaurant until today. So she nodded, as if she knew exactly what was expected of her.

Halle continued, "The most important thing is to learn how to read the customers. They come in three main types, the good, the not so good, and the ones you want to poison." Pointing through the crack in the door that gave a peephole view of the floor, she nodded, "Take that couple over there. Look like a pair of kittens, don't they? But you make one tiny mistake and they'll be screaming for your head on a plate. Whereas that heavy-set matron under the large plant basket, the one who looks like a brooding dragon? She's a real sweetie—very generous, always leaves a big tip. Speaking of gratuity, you might want to leave those top two buttons open. Our male clients tend to reward a small glimpse of heaven." Halle rolled her eyes skyward. "Okay,

let's look at you." Ana slowly twirled 360 degrees, confirming how well the white blouse and the close-fitting, black bib dress suited her dancer's frame. Halle whistled quietly, "Not bad! I hereby pronounce you ready and fit for the fray."

And before Ana had time to think, Halle had nudged her out into the dining room. Her life at the compass-rose was under way.

An hour passed, and as the tables started to fill the early birds were joined by a steady stream of couples and larger groups. Halle watched Ana out of the corner of her eye. It was obvious from the way she held the big trays of food and the manner in which her gliding hips swiveled between the tabletops that she was a natural. Halle thought of the waitresses as swans or geese. She noted with a certain satisfaction that her protégée contained not an ounce of goose!

Ana, on the other hand, did not feel anywhere near as confident as she looked. Her brain was working overtime, trying to remember who had ordered what, and the starched black and white uniform contrived to make her movements feel brittle.

Halfway through the evening, Halle took Ana's arm and led her over to a table where a young man was sitting alone. "This is Zephyr, my new lodger. He's been pestering me all evening to introduce you to him." Slender as a sapling, Zephyr rose from his table and shook Ana's hand, making certain that she received the full benefit of his bright gaze. Ana was too preoccupied to pay much notice, but she did register Zephyr's hands. They were very long, quite cool, and badly scratched.

Even though it was midweek, the restaurant had filled to bursting by nine o'clock. A controlled pandemonium slowly took over, fueled by three black-clad fiddle players who were perched on the small stage at the compass center. These wiry old men apparently had an inexhaustible supply of energy. As their bows wildly sawed, the fiddles' rhythm propelled Ana and the other servers around and around the babbling room. Ana did her best to keep up with the more experienced waitresses, who flew between kitchen and tables faster than the pigeons entered and exited the casement windows.

It was intensely exciting and it reminded Ana of the Capolan Spring Feasts. Surely the place couldn't be like this every night?

Now and then Ana passed Halle, who from the corner of her mouth made comments about various customers. At one juncture Halle whispered, "Table twenty-two—lives with his mother. They say he's a little too familiar with the family pet." Ana couldn't hold back her laughter and in her distraction crashed into a balding businessman who was reversing his seat away from the table. The contents of a large bowl of tomatoes that she'd been balancing on one hand tumbled to the floor. Halle immediately dropped down to her knees to help Ana gather the escaping fruit.

"They're not going to fire me, are they?" whispered the mortified Ana.

"Don't be silly. This sort of thing is always happening," Halle said soothingly. "You're doing amazingly well. On my first night here I accidentally threw half a soup tureen over an imperial guardsman. I tried to clean the mess off his lap with a table napkin. He thought it hilarious, stood on the table, and toasted me to the whole room. Listen, if you have any problems, just bring them to me."

"You're being very kind," Ana said.

"We look after each other here," replied Halle.

Rising, Ana started toward the kitchen, but she found her way barred by a tall, good-looking man with wide shoulders and pale gray eyes. He held out a small plump tomato between his thumb and forefinger. He placed the undamaged orb in Ana's outstretched palm. His fingers grazed hers and, to Ana's surprise, a jolt of excitement passed through her. Embarrassed and not wishing to show this stranger the deepening flush of her skin, she hurried away, giving a muffled thanks.

A few moments later Halle touched Ana's arm. "He's gorgeous, isn't he? What did he say to you?"

Ana, still flustered, replied, "Nothing. Nothing at all."

Unlike many restaurants, waitresses at the Carta Rosa were expected to respond to customers both at their assigned tables and wherever else they were needed. Ana took advantage of this small freedom and temporarily moved to the southerly side of the room, away from the disconcerting presence of those pale gray eyes. Had he touched her hand on purpose? Was she mistaken, or had he squeezed the tomato as he gave it to her? Had he really noticed her, or was he just being courteous?

After a few minutes' debate, she managed to put him, almost, to the back of her mind in order to concentrate as hard as she could on being a good waitress.

The evening passed by in amazing haste. Ana could hardly believe it when Junto came out from his office and struck the bell that announced the kitchen's closure.

As the tidying began (a blatant message to the few straggling customers that it was time to depart), Ana became aware of a tall dark-skinned man leaning on a broom, thoughtfully studying her from the corner of the room. Under her breath and pointing behind her with her elbow, Ana asked Halle, "Who's that?"

"You mean the one with the broom?"

"Yes."

"He's called Sirocco. He started work the day before yesterday. He doesn't say much."

When the last customer had finally been ushered out of the door, the waitresses sat down together and were each given a glass of wine by Junto. "That's generous of him," said Ana to Halle.

"That's what you think. Those are the leftovers. Here, drink this instead. It may not be a '27, but at least I uncorked it myself." Ana took the replacement, sipped on the smooth, rich pinot noir, and leaned back to wallow in the camaraderie of her new profession.

Ana finally left the Carta Rosa around one o'clock. She was tired and more than ready for sleep. But waiting at the gate beyond the archway was the gray-eyed man. He approached and held out his hand. "I'm Boreos," he said. "Forgive me for intruding, but I knew I wouldn't be able to rest until I'd told you how beautiful I find you. Thank you."

Ana didn't quite know how to react to his thanks. Again she blushed as she wracked her tired brain for a suitable retort, but, without waiting for her response, he walked away.

Ana was used to receiving compliments. Ever since she'd crossed the bridge

from being a child to a young woman, she had attracted attention. It was both pleasant and difficult. The boys and men of the valley had made her feel special, but some of the girls made her feel like she had done something to slight them. Even her sister had become somewhat distant. There were advantages and disadvantages to possessing beauty.

She watched the retreating figure. She would have liked to thank Boreos for his compliment and might even have responded in kind, but he was already well out of sight.

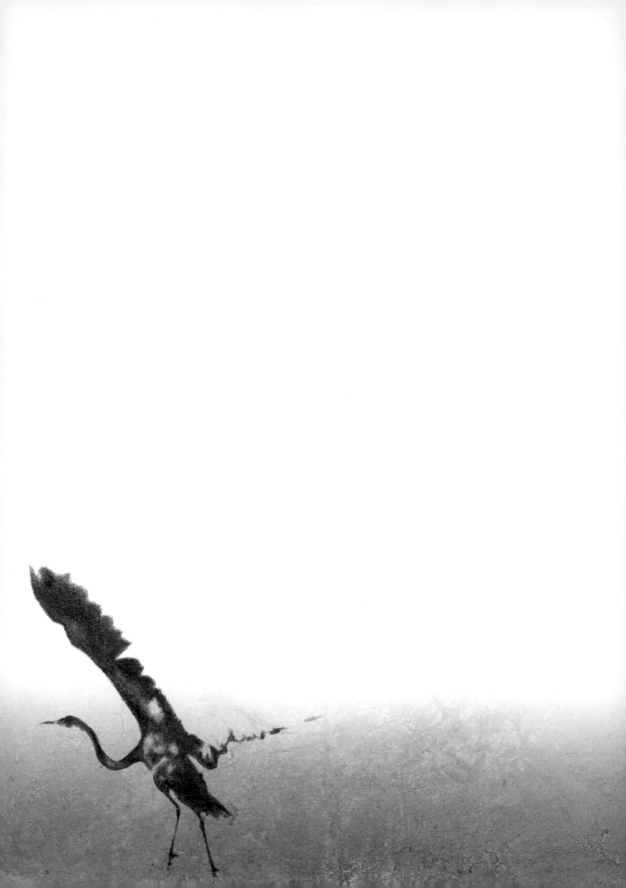

4

The following morning I awoke to the sound of what I took to be wood hitting wood. For a few moments my surroundings confused me, until with a rush the previous two days came back. I lay in bed savoring my delicious freedom, but then I jumped up, dressed, and headed downstairs. Madame Terantartini was in the kitchen hammering away with a large mallet at something that had once been alive.

I accepted my landlady's offer of breakfast, which was a mistake not to be repeated. However, while attempting to swallow the greasy pork and flint-hard bread, I asked her the question atop my list. "Is there a school of dance in Serona?" It seemed like that might be a good place to begin my search for Felix Bulerias.

Madame Terantartini thought for a few moments, and then said, "There you have me, dearie. I can't for the life of me be certain. But the university is up in the seventh quarter. Maybe what you're looking for is there." She walloped the meat again and asked, "Are you some kind of dancer then?"

I told her that dance was very important to me and that I was looking for someone who understood the traditions of my people.

"I used to dance a bit meself, when I was young." And with a cackle, she added, "Before I turned into a balloon!"

I walked up the seventh quarter and found the university. Unfortunately it was closed for the summer. In the office, a college secretary informed me that there was no school of dance, but, if I wished to return in the autumn, the college of music would be open again.

I was disappointed but in no way disillusioned. I hadn't expected my quest to be easy. I took the opportunity to look around the district, and I was wandering down a narrow street when I came to a music store with a dark green awning and a window filled with beautifully crafted instruments.

A well-dressed middle-aged man who was also looking through the window spoke softly, "Which one would you pick, if you had your choice?"

I wasn't certain if he was talking to himself or to me. He turned his head slightly and spoke again. "I think I would pick the shinobue, but I imagine you would select something less staid. Perhaps the chitarrone?" He was exactly the same height as me, with very short gray hair that made him seem slightly austere. His voice, however, was soft, rounded, and quite the opposite of severe.

"I'm not sure," I said. "They all look special. I think I'd have to play each of them, and then take a year or two to decide."

"Wisely spoken," said the man. "I envy you your patience and your musical aptitude. Alas, I do not play at all, so I am limited to selecting my purchases by sight."

"You collect instruments?" I asked.

"It's a fairly harmless compulsion." He looked rueful. "Unfortunately I only hear their song when someone else coaxes them to life. Which of these could you play, do you think?" he asked, spreading his hand before the window.

My modesty was being tested. I could either be coy or tell the truth. I pointed to the grouping of flutes and pipes. "Probably those," I said.

"Ah, the instruments of the wind." Reaching into his jacket, he took out his card and handed it to me, saying, "Mr. Hamattan. It is my pleasure to make your acquaintance." He paused as if coming to a difficult decision. "I wonder if I might ask you a great favor. Could I request a few minutes of your time to accompany me into this store and play something for me?"

I looked at the elegant typography on his card and then at the earnestness in his face. I could have refused without seeming impolite, but why should I? He obviously wasn't trying to accost me and I very much wanted the opportunity to touch the lovely polished blackwood flute and the waxed bamboo reed pipe. I bowed. "Ana Dijjo. I would be delighted to be of service."

I played the two instruments that I'd been craving to hold, plus two more of Mr. Hamattan's choosing. More than an hour floated by. All the worries and cares that had eaten at me during the last few days temporarily disappeared. The music filled me with such pleasure and certainty of purpose that I could hardly bring my attention back into the little shop. Mr. Hamattan sat very still, his chin in his hands, his ears pricked like an aye-aye. When I finished he applauded and I felt embarrassed.

We left behind a very happy storeowner. Mr. Hamattan had bought the blackwood flute and the shinobue, and he had agreed to buy a mandolin once the hairline crack I'd noticed in its bridge was attended to.

"How can I repay you?" he asked, when we were back on the pavement.

"Don't be silly," I said. "It was truly my pleasure."

"At least let me buy you some tea," he insisted, gesturing toward a café across the street.

I was thirsty and was going to get myself something to drink anyway, so I consented. Once we were seated, he politely asked me what I was doing in this part of town. I told him that I had intended to ask the shop owner if he knew of any dance teachers, but I had gotten so carried away with the music that I'd forgotten.

"Ah, you dance as well as play. What kind of teacher are you looking for?"

"There is a man—I was told he lives here in Serona—who knows the music of my tribe. I would like to ask his permission to study with him for a while."

"What is his name?"

"Felix Bulerias," I said.

"What makes this man special?" he asked.

"My grandfather says Dr. Bulerias is the only one left who fully comprehends the deepsong," I replied, feeling odd talking to a stranger about something so important to me.

"Forgive my ignorance, but what exactly do you mean by *deepsong*?" His curiosity was obviously aroused.

"That's hard to answer. And I'm not sure I can explain the cante jondo."

"Please try." He sounded almost earnest.

I paused to gather my words. "For me, it's a voice that comes from so far inside me that I do not choose or even really recognize it. It's what binds me to my people. They say it's the dark sound of an old knowing, terrible and truthful, harsh and accepting." Then, realizing I was sounding like a zealot, I added, "At least, that's what I understand.

He nodded reassuringly. "And is this deepsong something you dance to?"

"Not exactly dance to," I replied. "The sound comes up from the ground and when you fully open to it, your body begins to move to its call. That is the cante jondo. But I have never truly managed to attain the connection. That is why I am looking for Felix. I hope he will show me how."

We sipped our tea in silence, and then he said, "I have a number of connections here in Serona. Would you like me to inquire into the whereabouts of Dr. Bulerias?"

"That would be a bother."

"Not at all. We could call it an exchange of time. Now, tell me, do you dance as well as you play? If so, you must be very good."

I couldn't help but smile: his flattery was kindly meant.

"I know my limitations," I said.

"One person's limitation stretches far beyond another's horizon." He paused and drew a breath. "Would you, by any chance, consider teaching me to play the flute? I am utterly hopeless, but under your guidance, I am certain I could learn something."

I started to shake my head.

"Forgive me if I speak out of turn, but you have only just arrived here, I can

tell. As you are walking around during the day, I surmise that, like me, you are without gainful employment."

His reference to being unemployed seemed a little comical, because his clothes were clearly expensive and his manner suggested someone who was financially secure. I'd once seen a very rich man who had come to do business with my grandfather. Grandfather had told me afterward that he had known this man was truly wealthy because his fingernails were so clean. Mr. Hamattan also had very clean fingernails.

"A few hours a week, that's all I ask, and I'd pay you fairly. You can give me lessons in the park, so you don't have to worry about your reputation or any designs you may fear I have on your unblemished character." The latter he managed to say in such a way that it made any hint of seduction appear to be the farthest thing from his mind.

I was so surprised by this offer that I asked if I could think about it.

"Of course," he replied, tapping the table as if applauding my willingness to consider the possibility.

5

At the restaurant that evening Zoetta, one of the waitresses, handed Ana a note. "A customer gave this to me," she said. "He asked me to pass it on to you."

"Me?" said Ana, sounding slightly too interested for her own liking.

Zo swiveled her long neck theatrically to the left and then the right. "Don't see any other Anas around here, do you?"

"What did he look like?" asked Ana, with a feigned air of indifference.

"Amazing," replied Zo, pretending to swoon. "Sort of godlike and . . ." As she began her description of Boreos, Ana's pulse started to quicken.

After Zo had returned to the floor, Ana sat on the edge of one of the large, potted date palms that ringed the restaurant. The letter was folded into itself, creating its own envelope, and her name was inscribed in walnut ink. Ana broke the seal and unfolded the paper. The handwriting flowed easily, angled and confident. She noted, even before she had begun to read, how the tails of g's, y's, and f's swung downward, crossing into the lines below, passing through the words without damaging their legibility:

Ana,

I confess, I cannot get you out of my mind. I'm sure you have been told by many men that you are beautiful, so I will travel no further down that unarguable path for fear you might perceive my compliments as mere flattery.

Instinctively I know you are as kind and warm as you are attractive. Surely I'm not mistaken.

When I asked the girls at the restaurant they told me that you do not work during the day. Would you let me take you somewhere tomorrow afternoon? I have a place in mind that I think you would like.

Please say yes.

I will be by the river ferry dock at midday.

Boreos

She was instantly excited and angry at herself for being so easily stirred. Noticing her furtive reading, Halle sidled up and looked over Ana's shoulder. Ana pulled the note to her chest.

"Don't mind me. I always try to read other people's letters. Let me guess—a customer offering you salvation and a night of bliss?" When Ana didn't immediately respond Halle continued, "Of course, I'm just cynical. But, then again, it depends on who's making the offer. Which one sent it? That pony-tailed dandy, the one who dances with his wife but never talks to her?"

"No, not him."

"Who then? Wait a second . . . not that good-looking one who rescued your runaway carrot?"

"Tomato."

"My God, you've only been here a couple of days and you're already skimming the cream!" exclaimed Halle. "So, do I get to see the missive?"

Part of Ana wanted to keep it to herself. But Halle's conspiratorial manner was so compelling that Ana found herself passing the piece of paper over.

Halle hastily read it and then looked up. "Do you have something to wear?"

"I'm not sure if I'm going to . . ."

"Ana, for heaven's sake! Where's your sense of adventure?"

"I thought you were mistrusting."

Halle tipped her head from one side to the other as if weighing adventure and mistrust. "I don't see that they're exclusive!"

A *sense* of adventure: Ana turned the phrase over as she moved between the tables. She'd always believed she had good sense and surely, in leaving home, she'd embarked on an adventure. Did she have a sense of adventure, though, in the romantic way Halle meant? She told herself she wasn't naive. She had, after all, had a lover. An ardent boy at the camp whom she'd grown up with. But that had been about finding out, discovering what it was to touch and be touched. They had met secretly on the edge of the forest a half dozen times last summer. But when her parents had become suspicious she stopped seeing him rather than be forced into defending a liaison she didn't feel strongly about. For two months, she had enjoyed the excitement of their encounters but, in retrospect, understood them to be no more than play.

She knew there would be dangers in meeting Boreos—not because she thought he would harm her but because he was undoubtedly the kind of man who was experienced. Did it matter that she was probably merely one in a line of passing infatuations? No, she told herself, not if she kept that firmly in mind.

By the time she left the Carta Rosa that night she had decided to throw caution to the wind and see where Boreos would take her.

At Halle's request, Junto had begrudgingly paid Ana for the partial week she had already worked. Halle had also given Ana a dress that she said no longer suited her. It was too large for Ana, so she purchased scissors, needle, and thread and spent the next morning taking the seams in a little. At eleven o'clock Halle came by with a bracelet and earrings. When she saw the result of Ana's tailoring, she shook her head disapprovingly. "The dress is still way too loose. I insist that you make it fit your stunning figure."

"But I don't want to seem cheap," Ana replied, examining herself in the mirror again, wondering if she dared.

"You have a body that would turn an angel's head. If you don't take the dress in, I will cut it to shreds and then you will have to go in your undergarments."

Ana was flattered by Halle's compliments and gave in without too much of a fight. At a quarter to midday Halle decreed that Ana was ready for her tryst.

Just before she reached the dock Ana took off the earrings, then the bracelet. A second later she slipped the bracelet back on her wrist.

Boreos was already waiting for her. He was wearing a loose, open-necked white cotton shirt, his sleeves folded back to the elbows, showing his sun-browned forearms. His hair was slightly ruffled and considerably shorter than the dark manes favored by Capolan men. Under one arm he carried a large wicker basket and under the other he held a rolled carpet.

"Thank you for coming. You look lovely," he said. He appeared to be entirely at ease. Perhaps he always arrived at assignations laden like this.

A little awkwardly Ana asked, "Were you waiting long?"

"Hours and hours," he replied, clearly not meaning it.

She laughed at his exaggeration. He nodded down at the basket. "I suppose you can guess what's in here."

Ana, who had never encountered a picnic hamper, shook her head.

"Better and better. Are you ready to go?" he asked, indicating with his head the side street opposite.

Not wishing to seem too trusting, Ana asked, "Do you intend to tell me where we're going?"

"Afraid not. You'll just have to wait and see. Come on," he said, leading her into the narrow, winding streets that made up the oldest part of the city.

Like partnering a strong dancer whose movements one echoes, Ana found herself enjoying Boreos's assuredness.

"Have you lived in Serona long?" she asked.

"A short while longer than you, I believe. Though I've passed through the city many times."

There was something in the way he answered this and her subsequent questions that seemed almost equivocal. It was not that he was evasive. In fact, the conversation flowed easily. It was that Boreos, while avoiding the pitfall of seeming too knowing, gave the impression of someone who had traveled much and was well versed in the ways of the world.

His accent was fascinating, both rough and smooth, and after a while the meaning within his words seemed less important than the cadence of his delivery. A comfort settled upon her that she realized stemmed partly from his easy manner and partly from his physical size. He was about the same build as her grandfather, with an imposing frame that caused people to instinctively step aside for them. The pair made an attractive couple whom passersby couldn't help but notice. Women would cast Boreos sidelong looks of admiration, while the men who would normally have taken their time studying Ana's beauty settled for a hurried glance.

Ana had always held herself tall, and her stride was strong, regardless of her environment, but now she started to understand how important it was to carry herself with poise while in the city.

Boreos led her to the weaving district, where he turned into a small stone courtyard. Stopping in front of an old doorway and dipping his shoulder toward her, he said, "There's a key in my shirt pocket."

With two fingers Ana delicately fished out the small, copper-colored key, taking care not to let her knuckles brush against his skin. He nodded toward the door and she placed the key in the lock. It turned with surprising ease, as if the

barrels had been recently oiled. Without pausing he entered ahead of her and began to ascend a flight of stone stairs. He had to twist slightly sideways in order to maneuver the hamper. The rolled carpet under his arm obligingly bent itself against the wall, its edge picking up a plaster veneer as it went. Another door opened at the gentle nudge of his shoulder, and Ana followed Boreos into a room unlike anything she had ever seen. It was large and well lit by twenty or so small windows that rimmed the ceiling. Reaching up to the casements on all sides were shelves filled with slim spools of the richest of colored silken threads. Every shade, every tone, every hue imaginable.

"I'm told it's been left like this for over thirty years. The company went bankrupt. No one knew what to do with such small quantities of dyed thread."

"It's lovely," she said. "How did you find it?"

"I was looking for someplace interesting to make into my office and I was shown this."

"Are you going to rent it?'

"No, I bought it yesterday. But now I'm not sure if I'm going to keep it. It's not very practical for my purposes."

"That's rather impulsive, isn't it?" she said, marveling that anyone could follow a whim so easily.

"Hadn't you noticed I'm inclined to impulsiveness, Ana?"

Their eyes held. Ana pulled her gaze away before he could see her thoughts.

Boreos lowered the basket to the floor and unfurled the carpet. It was old and finely woven. Its colors matched the threads that surrounded them. Then

he opened the hamper. Ana half expected a cat or a ferret to jump out. Instead, Boreos began to lay out a picnic. Ana watched in wonder until he was done and had gestured for her to sit.

In the muted sunlight, surrounded by the delicious array of cilantro flatbreads, goat cheeses, oranges, purple grapes, smoked fish, quails' eggs, and red wine, they talked.

"Where were you before you came here?" she asked.

He shrugged. "I travel around a great deal. At different times of the year I'm obliged to do different things."

"What kind of work do you do?"

"You could call me a vulcanologist. I study the effect fire has on rock formations." He spoke with fervor. "Few people realize that, with enough heat, anything will melt—flames have a miraculous power to change."

Then, as if catching himself being too enthusiastic or maybe giving too much away, he turned the conversation back to her. "What about you? Even if I hadn't heard from one of the waitresses that you were a dancer, I could have guessed by the way you move. Have you always danced?"

"For as long as I can remember." Ana persisted. "Why fire?"

"For the same reason you dance, I imagine."

His answer caught her off balance. It was as if he really knew her. Did she want someone seeing inside her? She wasn't sure. He touched her arm and pointed to a spider and its silver pole, caught in the beam of sunlight angling from an upper window. The spider climbed up until the shadows consumed it. Boreos's hand was still against her arm.

Their meal was done and they arose, and only then did he pull her toward him and kiss her. She saw no point in pretending she objected and returned his kiss without coyness. They leaned into one another for a few moments—then she pulled away, saying, "I want to be sure of what I'm doing, first."

He was silent for a moment and then said, with credible chivalry, "You lead and I will follow."

They packed away the remains of the food, Boreos rolled up the carpet, and they retraced their steps to the other world. The streets were full of bustle, noise, and urgency and for the first time since she landed, she felt over-whelmed. If she could just hide for a little longer in the weaving room along with the indigos, the madders, and the olivesheens. If she could prolong the slide of her fingers across the silky carpet and smell for a short while longer the lemon water that Boreos had flung into the air to still the dust. If she could say she'd changed her mind and drag him back up to that wonderful chamber! But Ana could not take that kind of risk. If Boreos simply wished to conquer her and she let him, she would not see him again. And she was unwilling to lose herself in longing. Only when she felt more certain of her ground would she trust herself to him.

She took his hand and let him walk her to her lodgings.

6

Before she sent me off to meet Boreos, Halle had insisted that I visit her the following morning to tell her about my afternoon encounter. I arrived at the address and found myself doubly surprised. First, by the elegance of the house, and then by the young man perched on the high garden wall beside the front door. He had a shock of brown hair and was wearing a collarless, dark green shirt buttoned almost to the neck. His trousers, which were held by crossed suspenders (one blue, one red), were worn but well fitted, as were the brown leather riding boots that dangled not far from my forehead. He was no more than nineteen years old and seemed familiar. But from my vantage point I couldn't quite place him until I spotted his hands. I hadn't seen them clearly the other evening, but I'd felt them when we'd been introduced. They were long and thin and had recently been badly scratched. When I looked up again to his face I recognized his lopsided smile. "You're Halle's lodger. We met at the Carta Rosa," I said.

"We did." Then with a mischievous grin he continued, "You're the waitress who throws tomatoes at the customers."

I couldn't help but laugh. "It was my opening night! I wanted to establish a tradition."

He hopped down from the wall and landed close beside me.

"If you're here to see Halle, go on in. The door's open. She's upstairs." As he pointed, I noticed that the light emphasized his scratches and before I could stop myself I blurted out, "How did you get those?"

Looking at the backs of his hands, Zephyr examined the marks as if seeing them for the first time. "These? I got them climbing down a tree."

"What were you doing up a tree?" I said, thinking of the climb I'd recently undertaken.

"My plane got stuck there."

"Why did you take it up the tree in the first place?" I know I probably should have shown some concern for his well-being, but, to be honest, he just didn't look like he needed any sympathy.

Responding to my teasing, he raised his eyebrows sharply and explained doggedly, "My plane crashed in the forest and wedged itself into the top of a large oak."

I suddenly pictured the strange, mangled shape at the top of the tree. "I think I saw it," I said.

"You were near the forest when I came down?" he asked with surprise.

"I was walking through it. In fact, I think I may have been following you." I was recalling the slim figure in the distance, entering the maize field. It could easily have been Zephyr.

"I have something that may be yours," I said, digging into my bag. I rummaged around until I found the pocket watch. I handed it to him and he seemed a little confused. Then his face lit up.

"Where was this?" he asked, gripping the chronometer and twirling its chain.

"Hanging on a branch," I said.

"Thank you *so* much. I'd given it up for dead." He ran his thumb lovingly over the smooth casing.

I was about to ask him why it only had one hand, but at that moment Halle leaned out of the window and chastised me for keeping her waiting. I said good-bye to Zephyr and headed upstairs to appease Halle's rampant curiosity.

No longer clad in the Carta Rosa's colorless uniform, Halle looked very different. She was wearing a long, fitted, kingfisher blue dress and silvery slippers, and her red hair was no longer pinned up but curling softly about her shoulders. Her living room was at least three times the size of my caravan and infinitely more beautifully decorated, with rich velvet curtains, a lush oriental rug, and a large vase filled with lilies placed at the center of a polished rosewood table. I couldn't decide whether she fit the room or the room fit her. I was entranced.

I'd intended to ask her about her funny young guest but she gave me no chance.

"Well? What happened? Let's hear it! No detail is too petty."

So I told her. Not everything, but enough. I'm not certain why I was so open with her—maybe it was the way that the other waitresses seemed to treat her like their big sister.

Halle continued to question me enthusiastically until I called, "Enough!"

"Enough? Enough? You've thrown me a few salacious morsels and you say enough! You can't tease me like that and then leave me in the lurch!"

For a second I thought she meant it, and then I saw that she was playing with me. I picked up the nearest cushion and threw it at her. "Definitely enough about me. What about you? I don't really know anything about you."

"What do you want to know?" responded Halle, spreading her hands wide as if to say, What is there to tell?

"How old are you?"

She laughed. "You are a strange girl, aren't you? You're meant to work that out from little pieces of information I slowly give you. Not just come straight out and ask."

"Oh!" I stuttered. "I'm sorry. I didn't know that. Please don't be offended."

"I'm not," Halle replied "I'm forty-two. And maybe direct questions are more fun. Go ahead. Ask what you wish."

I took her literally and fired off a stream of questions. I found out that she was born in the Bene Canton. She had left home at fifteen and up until six years ago had wandered here and there. "Much," as she put it, "like the Capolan of old."

Her house had been left to her when her mother died. Her father had disappeared and her brothers had had no interest in owning a home, so it went to her.

"And the job at the Carta Rosa?" I asked, because I was starting to wonder whether she needed to work.

"We all have to have a structure to our day," Halle shrugged.

I asked her if she had been married and she told me that she had, twice.

"The first was a young man from the next town. We were hopelessly in love and ran away together. We were very happy for ten months, and then he drowned when a river burst its banks. I grieved for a year, before I finally took off. I met my second husband on a steamboat. He was the ship's first officer. We traveled the waterways for ten years until he too drowned. I think I must have offended the sea gods in another life."

I wanted to know if the second marriage had been as happy as the first.

"Yes and no," she replied distractedly, turning a strand of hair around her index finger and forefinger as if she were reeling in her memories.

"Has there been anyone since?"

She burst out laughing. "Of course there has. I'm a healthy woman! Am I not in fair fettle?" she said, getting up and twirling her skirt. The sadness that had been on her face a few seconds before was completely gone.

And it was true—she did have a fine form.

"After all," she confided, "a good bedfellow provides regular exercise and keeps the weight off my hips. Unfortunately, the cupboard I keep my lovers in is a trifle bare at the moment. But the occasional dry spell is good for the soul. By the way, what do you make of Zephyr? I've noticed him giving you those long, unblinking gazes."

"He seems a bit odd."

"I wouldn't say odd, exactly. More quirky."

"Do you have designs on him?" I whispered.

"Heavens, no!" laughed Halle. "He's way too young and slight for me. Now someone with a physique like your Boreos . . . " she added, lifting her chin coquettishly and smoothing her hair with the flat of her hand.

"He's not my Boreos."

"Not yet, maybe. But I bet you don't last the week without things changing."

That evening Mr. Hamattan was at the restaurant and he asked if I'd considered his offer. I said I had and would be happy to give him a few lessons on the flute. I suggested a trial period of maybe a couple of weeks. Obviously delighted, he again tapped the table with outstretched fingers. We quickly agreed on a time and place and I moved away to serve the next table.

Around ten o'clock, I noticed two men who had been drinking heavily amusing themselves by baiting their waitress, Zo. The more aggressive of the two had an ugly, unkempt mustache and was loudly mocking Zo's willowy figure.

"When she turns sideways you can't see her," he joked pathetically to his round-faced friend.

For a while, I listened to them poke holes in everything about her, from the way she waited on the tables to the shape of her nose.

I moved a little closer and when they demanded Zo bring them yet more wine, I stepped up to the table and said with as much civility as I could muster, "Gentlemen, perhaps you would care to switch to coffee?"

Swinging around toward me, the mustache snapped, "Mind your own business."

I remained externally calm and asked, "Black or white?"

"I'm not fussy. I'll have 'em whatever color they are," said the round-faced one, obviously finding his own remark hilarious.

I picked up their empty wine bottle and removed it from the table.

"Get us another one, Pox." Then to anyone who might be listening in the distance he slurred, "Why the hell does this place hire Capolan rubbish anyway?"

Maybe she saw me gripping the bottle neck tighter, or maybe now that the insults were no longer directed at her alone, Zo's voice emerged, shrill and penetrating. "How dare you?"

Halle arrived first. Summing up the situation immediately, and employing the tone of a seasoned officer commanding junior foot soldiers, she barked, "Stand."

Before they even realized they were responding, the two men stood up. Halle whisked away their chairs and announced to the spellbound restaurant, "No one gives these cretins another seat. Understood?"

The room applauded as if one.

By the time their two alcohol-soaked brains had taken in the extent of their humiliation, and before the men could become physically violent, Junto and three corpulent cooks appeared on the scene and escorted—or, rather, projected—them into the night air.

After making sure Zo was all right, I thanked Halle and Junto for backing me up. Halle dusted her hands extravagantly and said, "All in a day's work." Junto merely shrugged and followed the cooks back to the kitchen as if nothing whatsoever had happened.

7

The two men were waiting for Ana when she left the Carta Rosa. They stayed hidden until Halle and Ana had parted. Since the streets were quiet and Ana was exhausted, she wasn't paying much attention to her surroundings. So when one of them suddenly stepped out in front of her, she was startled.

"If it isn't that dirty little vagabond," he hissed through the gaps in his yellowed teeth.

Anger and adrenaline instantly spiked Ana's blood. She swiveled to establish a retreat. But the second man had slipped in behind her. Ana instinctively moved her weight to her toes, as the men slowly closed toward her. She waited until they were just a few feet away. Then she dropped her shoulder, feinted as if to run to the left, and instead broke to the right, passing the man in front of her before he could move his feet. Her arm flew out and her palm met his cheekbone as he tried to grab her. She was almost past him when the other man launched himself forward and caught a handful of her skirt. She twisted to pull free but this gave the first man the opportunity to grab her arm and swing her against the wall. Both men were on her. The first held her by the

throat. The second was trying to get a grip on the front of her blouse when a howl of pain burst from his mouth. He dropped to his knees too late to protect the kidney that had just been severely bruised. Before the first man could react, he was struck violently behind one ear and then the other by the end of a broom handle. As soon as he removed his hands from Ana's throat, she reached back and drew the narrow blade she kept sheathed at the base of her spine. The stunned man felt the tip of the knife against his groin. He backed away and tripped over his prone colleague, smashing his head on the curbstone. Standing over the tangled heap, Ana now saw the dark figure of the floor sweeper, Sirocco.

Still fueled by a righteous anger, Ana badly wanted to drive her knife into someone's flesh. It took her awhile to separate friend from foe. Without taking her eye from Sirocco she twisted the blade and reinserted it into its sheath. Finally she nodded, acknowledging Sirocco's part in her liberation. Then, stepping between the two horizontal figures, who were obviously still in an advanced state of suffering, Ana trod with all her weight on the closest ankle.

Sirocco smiled. "You do not look the type to carry a knife."

Ana sighed, her knees starting to feel shaky. "My mother . . . she insisted my father teach me." Then, remembering her failure to show gratitude, she respectfully thanked Sirocco for his assistance. "The debt shall be mine, until repaid."

The smile gone as fast as it had come, Sirocco accepted her thanks and suggested that they leave before further trouble ensued.

Ana walked half a pace behind him, her mind whirling. Never in her life had she been that furious. Where had it come from, that violence? Certainly, they deserved to be paid back. But the pleasure she had felt when she brought her full weight down on his ankle? Had she changed that much in such a short space of time?

Sirocco escorted Ana to her door, waited until she was inside, and vanished.

Standing at her window, Ana stared out at the quiet street, wondering how Sirocco had known where she lived.

Fear and harsh experience make some individuals quake, while others look to sleep to soothe their distress. Ana's reaction was to dance.

She moved slowly around her little room, her electrified hands and arms spinning a complex pattern, her mouth open to a song beyond even a dog's hearing.

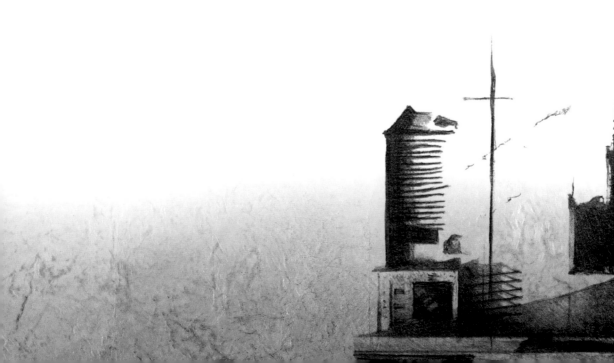

8

When we'd parted two days before, Boreos had asked if I'd like to accompany him when he went to look over some unusual lava stone in the Caloras Del Castor, to the north of the city. "I apologize," he'd said, "for mixing work and pleasure, but I think you might find the volcanic formations fascinating."

I liked it when he spoke to me with an element of formality like that. It was as if he took nothing in me for granted. It was also, almost but not quite, a contradiction of his usual air of confidence.

We had agreed to meet early to make full use of the daylight and, as before, Boreos was waiting when I arrived. This time he greeted me by kissing me on my lips. I wasn't sure whether to admonish him for his forwardness or to respond in kind. After a short internal consultation I settled for the latter.

It took around an hour to ride up the Caloras coast road and we chatted easily for most of the way. I decided not to break the mood by recounting the previous night's incident.

"Tell me about your family and where you come from." Boreos's tone, although soft, held the barest hint of command. And to my surprise, instead of

resenting that tone of authority, I found myself wanting to comply. I realized how much my growing physical desire for him was in danger of conflicting with my usual clarity.

I described my home, my parents, my grandfather, and even my dog. As I was speaking, I could feel myself becoming homesick, and a lump started to grow in my throat. The last thing I wanted to do was to start crying, so instead of telling him about the marriage ceremony and how I'd run away, I skipped to my arrival in Serona and finally managed to escape the subject of myself. "Why did you come to Serona, Boreos? Was it a matter of business?"

"In part." He said that he had had little opportunity to examine crystalline rhyolite at its source and wanted to make the most of his stay in the region. I casually inquired how long he intended that to be. "That," he responded, "depends on how long it takes us to fulfill our responsibilities."

"When you say 'our,' do you mean your company?"

"Yes, I suppose we are in a sense a company."

This was odd, but I didn't want to pry. And, in truth, I was rather liking Boreos's air of mystery. There was something intoxicating about his mixture of solidity and elusiveness.

"Almost there," Boreos announced, turning sharply down a small lane.

The Caloras was not what I'd expected. Talk of rock and volcanoes had led me to imagine a barren, mountainous region. It was, in fact, a fertile district with sloped hills, olive trees, and vineyards.

Toward the end of the rutted road, we were met by someone Boreos had described as the local expert. Sebastian Metadan turned out to be a friendly

enough man if rather peculiar in appearance. His long, thin nose, erratic tufts of temple hair, and threadbare morning coat gave him the look of an underfed heron. Boreos shook Metadan's hand and introduced me as his "companion." They spoke for a few moments about the general lay of the land, pointing this way and that, Boreos making undulating movements with the flat of his hand. For some reason I had assumed they already knew one another, but their conversation soon made it obvious that they had only very recently made contact.

Metadan walked us a short way up the steepest of the surrounding hillsides until we came to a rocky outcrop that was hidden from the road. "You'll find that the entrance to the cave narrows just behind that cypress. It's no more than three hands wide. Inside, I think you will discover what you're looking for."

The two men shook hands again and Metadan departed, presumably leaving the two of us to explore the depths.

The entrance was covered in a thick matting of purple ivy that Boreos had to peel back. "Don't tell me we're going in there," I said, horrified. The darkness of the night forest was nothing compared to the blackness before me.

"It's all right," replied Boreos, producing a pair of torches from his large leather bag. "I'll go first."

If it had been anyone else I'd probably have stayed behind in the balmy sunshine. But I didn't want Boreos to think me weak. So I inhaled deeply. "And I'll go second."

He plunged into the fissure and I followed.

"I can't see anything," I gulped, feeling the panic rise.

"Shine your torch downward and concentrate on where your feet are going," he said calmly.

"But I can feel the roof practically scraping my hair."

"Just duck. The tunnel will open out shortly."

I was beginning to be infuriated by his lack of concern. However, I followed his instructions and the claustrophobia subsided almost immediately. As he'd predicted, the cavern soon opened up and we were able to stand straight without risk of hitting our heads. My trepidation lessened, and I began to be able to take in the new experience.

"Do you have a compass?" I asked.

Boreos laughed. "No. I usually have a fair idea where north is."

As we began our gradual descent I stayed close behind him, allowing his light to lead the way while mine trailed across the sides of the cavern. After a couple hundred yards, the walls changed from dull to slightly shiny and light started to reflect back from the occasional crystal that jutted out from the ceiling. I wanted to pluck one but I was worried that I might bring the whole roof down.

The temperature had risen. I hadn't expected that. If anything, I'd thought it would be colder underground. I peeled off my coat and threw it over my shoulder. I dropped back half a pace from Boreos and watched him moving confidently into the darkness. I couldn't resist occasionally directing my beam at his shoulders, his back, and his strong legs. I had an urge to leap on him and have him piggyback me to the heart of the earth.

We'd been moving forward for about twenty minutes when he slowed, pointing to the ground where the rock had taken on a texture similar to the thick, wrinkled bark of an old tree trunk.

"That's pahoehoe. It's solidified magma that's been forced up this tunnel from the main shaft. We're almost there," he said. "Hold my hand."

His grip buried my fingers completely.

A few seconds later, we emerged into a gaping chamber. I swiveled my torch around but could get no real sense of the scale of the place. Boreos said, "Stay still," and he took from his bag a large lantern. He set it down on its tripod and turned it on. Immediately the chamber lit up. We were standing on a circular ledge carved around the inside of a huge vertical tunnel of petrified lava. I looked down and saw the tunnel falling away into unimaginable depths. My eyes lifted and I saw the curved walls rising to a tiny porthole of sky hundreds of yards above us.

Boreos put his arm around me and squeezed my shoulder. "In case you are concerned, this volcano has been dormant for well over two hundred years and will remain so for another hundred."

"How can you tell?"

"The lava's shape and color give away its history."

"No. I mean how do you know that it won't erupt for another hundred years?"

As Boreos started to wander off into a side passage he laughed over his shoulder, "Oh, I just said that to make you feel safe." A few moments later he called out, "Here it is."

I didn't know what *it* was, nor was I going to follow him in order to find out. The sound of a hammer chipping at rock echoed around the cave. Then it went extremely quiet.

I leapt at the sound of his voice behind me. "This is what I came here for," he said. "It's a very unusual type of rhyolite. See how variegated it is."

I thought it totally lacking in charm, but I didn't say so. I just emitted a sympathetic "Mmm."

He looked at me. "I suppose it isn't *that* exciting," he admitted. "But I don't get to see much of the underworld these days." He turned the stone lovingly in his hand, and I could see that my lack of enthusiasm had not dashed his in the slightest.

He put the rhyolite in his bag, buckled the strap, and kissed me, his mouth on mine, not pressing hard, just staying there, allowing the contact to excite me. I put my hand up to his neck and threaded my fingers into his hair. I needed him to touch my body, but he pulled back and smiled. He's teasing me, I thought. He knows I want him.

I determined that I wasn't going to let him have things all his way and, not to be outdone, I led the way back, making sure that, this time, his eyes were focused on me. As we climbed near to the surface Boreos came close and rested a hand on my hip. He began whispering the words of a song I'd once heard, late at night, coming from a neighbor's caravan, "One dark night, in the falling rain, by the light of your eyes, I lit my way. Now, when we are alone, and your dress rubs against me, a shudder runs deep in my bones."

I was certain that Boreos had used those words on other women, but I didn't mind. Their effect was barely diminished.

When we finally broke to the surface, the air that had seemed warm before we entered the cavern now felt cool by comparison. We kissed again and Boreos asked me if I was hungry. I nodded and he suggested we eat at one of the vineyard cafes we'd passed on the way. Being strangers to the region we had no means of knowing which to choose, so we picked the Monk's Figleaf, partly for the name and partly for its elegant bell tower.

At the counter, we sampled a few wines, made our selection, and went to sit at one of the balcony tables. The sun had only recently begun its downward arc and the light on the tablecloth was brilliant.

"Tell me why dance is so important to you," he asked, once the waiter had placed a large dish of fried octopus between us.

I stabbed a piece with my fork and reflected that this was the second time in three days I had had to explain my dancing to a stranger. But where Mr. Hamattan had been politely attentive, Boreos was downright distracting. I swallowed the tip of a tentacle and began slowly. "I have danced since I was a tiny child. My grandfather would watch me and say to my parents, 'She hears it. One day she'll show us the way out of here.' I didn't know what it was he was saying, because I didn't understand then that you can hear with a part of you other than your ears. When I pressed him to explain, he said that I was listening with my belly. I can remember getting this picture in my head of a big pair of ears floating around inside me along with my dinner."

Boreos grinned. "But what does dancing feel like to you?"

What I could feel was Boreos's leg resting against mine, under the table. "It feels . . . right. As though I'm doing what I'm meant to do. On a simple level I feel the pleasure of moving my body to the rhythms of music. That's only part of it, though. When I grew older, my grandfather started to teach me about the earth's magnetic guidance."

"Tell me about that," Boreos said, leaning toward me and increasing the pressure of his knee on mine.

"Do people believe in the earth's pull where you come from?"

"No. We tend to concern ourselves with what we see and can touch." He stroked the back of my hand with his thumb. "As you have seen from today's excursion, forces below the ground fascinate me. What do you mean by 'magnetic guidance'?"

A hawk glided by, no more than ten feet from the balcony, utterly assured in its ability to ride the currents of air at will.

"I was taught that beneath us the magnetic rivers of the earth are in constant movement and that each person is guided by his own stream. If we follow our guide we stay strong. But if we lose our course, we come to a halt and stagnate. My grandfather's friend Felix says that each clan has its river and that if a dancer is in sympathy with the tribe's magnetic current, then he or she will become the conduit that is able to point the clan's way forward." I turned my hand over so that his thumb was in my palm, then I closed my fingers till they lightly encased it.

"But what of the heavens? I thought they played a large part in your traditions."

"Capolan tradition says that the winds will help direct us back to our magnetic rivers if we are lost."

He pursed his lips and blew lightly on our touching hands. Without seeming to choose to, my fingers gripped his thumb tighter. "Are you saying that you think the winds and these underground rivers are in some way tied to one another?"

"Not exactly," I replied, finding it harder to concentrate on the words coming out of my mouth. "I believe that here, above, and below are intertwined in a way that cannot be fully comprehended. But that does not matter, because if I were somehow able to stand over our lost fountainhead then just maybe I could perform the one dance that truly matters to us."

"That is very noble," he said, in what I took to be a slightly paternal tone, "but what if your kin have no wish to be led?"

I released his thumb. "Do you think my ideas childish?" I responded defensively.

"Not at all." His hand moved to my arm. "If only every young woman had your enthusiasm, and brilliant eyes, and shining black hair," he squeezed my forearm, "and exquisite skin . . ."

More food arrived, as did a second bottle of wine. We ate and drank, and Boreos led me away from my seriousness. He turned all his charm into paying me elaborate compliments about what he called my "passionate intensity." I was unused to so much attention and though, at first, I tried to deflect his remarks, I gradually slipped into a balmy trance where I would have done almost anything to keep the stream of flattery flowing. But the afternoon

could not go on forever, and, as the shadows began to lengthen, we were forced to think about our return to Serona and my evening shift at the restaurant.

As we were leaving, Boreos must have noticed that the door to the bell tower was half open, because he slipped into the stairwell and pulled me in with him. Emerging into the light again at the top of the tower, we were provided with a 360-degree view across the valley. Someone had placed a chair on the turret flagstones, presumably for contemplation.

Boreos took me by the hips and fed me back, down, into the chair. He leaned over me and kissed the side of my neck just below my ear. Then he kneeled before me, looking directly into my eyes. His palms rested on my knees. His arms moved outwards, pulling my legs slowly apart. His hands moved upward, thumbs running parallel tracks beneath my skirt, his forearms pushing back the flimsy cloth as they traveled. He dipped his head and he gently bit the inside of first one, then the other thigh. I closed my eyes and felt his fingers move higher. I heard him start to unhook his belt buckle and knew that any argument I might have with myself over caution would have to come much later. He pulled at me gently and I slid toward him. For a fraction of a second I was somewhere else, standing before another tower, asking for liberation. Then we heard the stair door creaking and I immediately sat up and pushed my skirt back over my exposed thighs. Boreos stood up and hoisted me to my feet. We waited a few seconds but no one appeared. Maybe they sensed we were up there and decided not to interrupt us. Maybe it was the wind or a cat. It didn't matter—the moment was broken. My head clearing, I gave Boreos a smile, took his hand, and led our retreat.

The return to Serona was a pleasant ride through a shadowing countryside, Boreos making sure he showed no signs of disappointment. As we entered the city the street lamps were starting to come on. We parted outside the restaurant—one more embrace, and then I was alone.

In a way I was glad Halle wasn't on duty that night. I didn't want her asking about Boreos. I wanted him to myself for a few more hours. The Carta Rosa was uncharacteristically quiet, and midway through the evening I took a short break in the porchway behind the kitchen. Sirocco came out and sat beside me.

"Have you recovered?" he asked, genuine concern resonating in his voice. It was still a surprise to hear him speak. For some reason I thought he was talking about Boreos and the bell tower, and then I realized he was referring to the fight outside the restaurant.

"Yes, I'm fine," I said, leapfrogging back to the previous evening. "Thank you. You came out of nowhere."

"I saw them skulking in a doorway and I could foresee a problem."

I pointed to his broom. "I'm glad you had that with you."

"There's more than one use for most things."

Renee, one of the other waitresses, came outside and stood nearby. "Either of you have a light?" she asked. I shook my head but Sirocco produced a small flint box from inside his work coat and lit her hand-rolled cigarette.

"My God, what museum did you get that from?" she teased, obviously amused by his antiquated lighter.

Sirocco slipped it back into his pocket with a dry smile.

"Well, it does the job and that's what matters," Renee thanked him. "Don't let me disturb your little chat," she said, moving away to lean against the wall and closing her eyes, the better to concentrate on the pleasures of her cigarette.

"How long have you been in Serona?" I asked Sirocco.

"Not much longer than you."

"What brought you here?"

"I suppose you could say I was called," he said, turning his head away and setting free a surprisingly infectious chuckle.

The laugh changed my picture of him. I examined the outline of his strong high-bridged nose and the stubble hair capping his powerful head, thinking how little I knew of the people from the Southern deserts.

Then my name was shouted and I had to return to the kitchen. Again I spoke the words, "I am indebted."

9

Mr. Hamattan had not exaggerated his lack of musical ability. The first lesson was a disaster. Ana knew almost immediately that she had a colossal task on her hands. It wasn't that he couldn't hear properly. His was a different kind of disability, one that seemed to encompass almost everything related to playing a wind instrument. His lips didn't fit mouthpieces and his fingers seemed incapable of selecting one note. Which seemed a little peculiar because the rest of the time, his hands were far from clumsy.

They were sitting facing one another on adjacent benches in a quiet corner of Trubados Park, having arranged their get-together a few nights earlier. Mr. Hamattan had brought with him three instruments: a small musette, a carved bone hornpipe, and a delicate little bamboo flute.

They were collectors' items, beautifully made. And Ana handled them with respect and a little awe. She showed him some finger positions for the hornpipe. He looked horribly awkward holding it and the sounds he produced kept even the crumb-hunting squirrels at bay.

Ana picked up the flute and tentatively blew across it. It took her a few seconds to adjust to its sound. When she felt comfortable, she played a few bars of a simple melody. She couldn't keep the smile from her face: its tone was exquisite. Mr. Hamattan sat with his knees together, his hands draped over them, and his attention fixed on Ana's lips.

She handed him the flute, encouraging him to try. He tried. He tried, and then he tried very hard; yet all he could produce were noises akin to ripe fruit being squashed.

Mr. Hamattan was not downcast. In fact, he maintained a healthy grin. He apologized for his ineptitude and said he was learning much. Ana doubted it, but she couldn't help admiring his irrepressible enthusiasm.

They sat on the bench for nearly two hours. Progress continued to be slow, if not nonexistent, but that seemed to matter little to Mr. Hamattan. When Ana finally declared the lesson over, Mr. Hamattan put away the instruments in their cases, thanked her profusely, and proposed a short walk around the pond.

"I have news for you about Dr. Bulerias. He was here in the city until about six months ago, but no one has seen him since then. There is a rumor that he has left the country for a while." He caught sight of Ana's deflated expression and continued, "I'm sorry if that's a disappointment to you. I will make further inquiries."

"Thank you," said Ana, "I had been led to expect that he would not be easy to pin down."

They were, by then, circling the pond. Mr. Hamattan talked about water and particularly its sound. He told her that he built experimental instruments

of his own, ones that were operated by running water. "Having heard my pitiful efforts, you will understand why I seek perfection in the elements."

Ana said that she'd never heard of a water-driven instrument. He replied that they were uncommon even in his homeland. She wished to hear more about his creations but they had reached their starting point and Mr. Hamattan had to leave.

Coming back through the park, Ana spotted a familiar figure standing on a grassy hummock. He had his back to her but she knew from his clothes and the mop of hair that it was Zephyr. He was leaning back, both arms raised to the sky, a taut thread straining in either hand. The two lines stretched upward until they joined the tiny kite that danced far above them. Ana stood watching as the paper falcon flew from side to side. Zephyr would twist and snap his arms first one way, then the other, and the kite would move to left and right as he decreed. He made it loop and circle, flip and dive, seeming to have total command of the kite and the air surrounding it. The young pilot's body may have been slight, but there was clearly nothing the slightest bit frail about it. She quietly chastised herself—it felt indulgent to be assessing Zephyr while Boreos was so much on her mind. She quickly moved her gaze away from his lithe form. As she looked around, Ana gradually noticed that the trees weren't rustling at all. There was no wind whatsoever at ground level, yet overhead there must have been a great deal. The more she observed, the more peculiar it seemed, this stillness on the ground and the frantic darting of the kite. She

considered asking Zephyr about this phenomenon—he was, after all, a pilot and would surely have an explanation—but she didn't want to disturb him. He was obviously so engrossed in what he was doing that he hadn't noticed her presence.

Walking away, she was totally unaware that her name was being etched over and over against the clouds by the path of the little kite.

Again that evening Sirocco came and sat with Ana during her break. He said nothing for a while, and then he began speaking quietly, "Ana, I have heard that your people lived for six hundred years without a land of their own."

"So I have always been told." Instinctively Ana felt a little guarded.

"And is it also true that they have now stopped traveling from place to place?"

"Yes," said Ana, growing more curious to hear why Sirocco was asking such questions.

"Why? Why have they stopped?"

Ana noticed the concern in his voice. "Because we have lost our way," she said. "Because we have grown lazy or tired. I don't truly know. Maybe we no longer know how to go or how to stay."

After a pause, he spoke again. "They have lost their sense of timing. But you, you listen to the movements beneath your feet. It unsettles you that you cannot find the rhythm?"

His insight was disconcerting. "Sirocco, how is it that you know so much about me?"

"I observe only that which is obvious," he replied with a shrug. Then, seeing in her face that she didn't understand, he elaborated, "Our history is carved

into us. It's in our shape and in all our actions. There's no curtain of sand. No mystery."

His explanation was not unreasonable, yet Ana still felt somewhat exposed by the sharpness of his perception. She attempted to make light of the conversation. "And what else does the Almighty Seer see?"

"You laugh at me, but I believe your question begs an answer. From where I stand I see three competing elements: fire, air, water." With that, Sirocco took up his broom and returned to his work.

10

I couldn't wait to see Boreos again. I was ready to continue where we had left off. I enjoyed talking with him, but conversation was not foremost in my mind. And, in truth, I was quite certain that he was not the kind of man who would fall hopelessly in love with a wandering tatterdemalion like me, so I felt no qualms in taking fate's offering.

He met me in the early hours of the morning after I finished work. He encircled my waist, picked me up, and spun me round just like my grandfather used to after I'd brought Grandma flowers or when I'd played something special for him on my flute.

"I presume your landlady would not take kindly to a late-night visitor. Would you consider coming home with me?"

"Is my honor safe?" I asked.

"Almost certainly not," he replied.

"Then I accept."

His house was not far from the old Hippodrome and it was a perfect fit for him. It was lit from the garden by two gigantic orchid-shaped lamps

and was completely asymmetric. The facade looked as if it had been shaped from lava and petrified flames. Even the windows and balcony made me think of the rocks at Caloras.

Our lovemaking began as soon as we passed through the front door. It continued on the sweeping stairs, in the hallway, and into the bedroom. His bed engulfed me, as did he. There was an unquestioning directness about everything he did that dispelled all sense of limitation within me. His energy and desire barely faltered.

Occasionally, I'd pull free and close my eyes for a few minutes. But then we would begin again, he with me or I with him. The edges between us blurred and I felt as if my skin were seared to his. In sleep, I saw the bonfire at my abandoned wedding and the dissolving sparks wasting in the damp night sky. In wake, I dreamed of Boreos, a white flame moving within me, feeding my limbs. By morning I was sinewless, my muscles perfectly exhausted. All my anxiety temporarily borne away.

A couple of hours after dawn I arose and wandered around the house. Boreos had finally fallen asleep, his head resting on the crook of his muscular arm. His home swirled around me. Wherever I turned were curves and twists. Each room was a different shape, size, and color. The furniture, the carpets, all seemed to flow from the same being. But this building was much older than Boreos. How then, I wondered, had he come to own a place that so closely matched his taste? It felt like the rooms were constructed from thousands of tiny mirrors, each aimed at Boreos. But perhaps it belonged to his family. He

never spoke of his kin, whereas I talked of mine too often. What did I know of him? His life? I could still feel his pull, but desire no longer overruled my capacity to think. Why did I not fully trust him? He was there but not there. It was as if he were acting out a part.

I returned to the bedroom to find Boreos climbing out of bed. "I've been thinking," he said. "That weaving room. Would you like it as a dance studio?"

I stared at him in disbelief. A fleeting glimpse of myself dancing amongst rich threads made me giddy.

"I thought it was going to be your office."

"I've changed my mind."

"Why? It would be a marvelous place to work."

"It would suit you better than me. Take it."

"I couldn't remotely afford it," I said, doubt growing into resistance. His generosity, if that's what he intended, felt like patronage. And I knew I was being offered the keys to a beautiful cage.

"Call it a contribution to the arts."

I had been intending to get back into bed with him, but suddenly I didn't really want to.

"You are being too generous," I said, "and I don't want to be beholden to you."

The look on Boreos's face showed his realization he'd moved too soon, over-stepping a boundary. "Ana, it's yours if you ever want it. I won't be using it in the near future."

I started to dress.

"Come here," he said, changing his tone.

"No," I replied, wanting to stand my ground on all fronts. "I need some time to myself. I have a busy day ahead of me." I quickly kissed his cheek, thanked him for the night, and took to my heels.

"I think you were right to turn down his offer," said Halle, "but why did you beat such a hasty retreat?"

I was sitting in her kitchen, my hands wrapped round a warm cup. "Because there's something about him that's not quite right," I said. "And besides, I cannot be bought."

She smiled as she poured me more tea. "What exactly do you mean when you say something's not right?"

"It's hard to describe. He's *too* perfect. *Too* handsome—if that's possible. He speaks *too* smoothly. Everything about him is curved, but he moves in straight lines. I feel like he wants me to be addicted to him."

"Surely you aren't falling in love with him already?"

"No. No. He knows how to charm and he certainly knows how to make my body feel wonderful. He's infused me with a sense of great passion. But it's not a passion for him. It's an enthusiasm for life. I feel like I've been given the energy to dance halfway round the universe. Boreos is attentive, but I don't trust him. I get the sensation he's outside watching both of us, even though he's in the room with me. I know that doesn't make sense—it's just a feeling."

"It makes very good sense to me," interjected Halle.

"Maybe what he wants of me and what I might want of him are the same, but I cannot take any chances."

"How so?"

"I've only just arrived in Serona. I have a responsibility, an obligation to fulfill. Yes, I want to learn more about love, but I will not let my heart be ensnared by someone like Boreos."

Halle looked hard at me. "I think he underestimated you, Ana. And maybe so have I."

We stayed in the kitchen and talked for most of the morning, our friendship continuing to grow. Around noontime, Halle asked me if I liked where I was living.

I admitted that it wasn't exactly home.

"Would you be interested in living here?" asked Halle. "Zephyr contrived to frighten away my other lodger. She left yesterday."

"Are you serious?"

"Yes, she was a rather private girl who became distressed when Zephyr wandered, naked, into the bathroom, while she was cleaning her teeth."

"No. I meant about the room?"

She laughed. "Of course. Would you like to see it?"

So it was settled. I went back to Madame Terantartini's to give notice and to collect my small bundle of possessions. There was a note waiting for me from Boreos, asking me when we could meet again. I folded it and slipped it into my skirt pocket. From my old residence I went straight to the market to buy myself a few necessities and get my new landlady a present.

When I got back to Halle's house the windows of my new room had been thrown open and there were fresh linens on my bed.

"It's good that neither of us has work tonight; you can join Zephyr and me for dinner," said Halle.

And this I did, celebrating with them my arrival in Serona and Halle's home.

After dinner Halle began clearing away. I started collecting the plates, but she insisted I stay seated and get to know Zephyr better.

"Have you ever flown?" inquired Zephyr.

"*No!*" I replied. "I'm not that crazy."

"Wouldn't you like to go up there into the winds' mercy?"

"*No!*"

"But I thought the Capolan revered the wind."

"I do. I also understand the power it has over us." Then, resting my left elbow on the table, I flew my right hand into my left, wedging it amongst the spread fingers. I laughed, "I'm surprised you've forgotten so quickly."

In mock humiliation Zephyr dropped his head to his chest and then lifted it quickly. "Pilots are like that. They are eternal optimists. We fly on."

"But you don't have a plane anymore."

"True, but I intend to build a new one."

I couldn't help but like this boy. He was young; younger, I thought, than me. But his incorrigibility and his willingness to act out his dreams made him very appealing. "Where did you fly here from?" I asked.

He pointed to the west. "I'm on the run . . ." he said lightly.

"From?" I asked, growing curious.

He frowned. "From war and hunger and greed and revenge." His personality seemed to change. Lines appeared on his face that shouldn't have existed in someone his age. Then, not giving me a chance to question him further, he shook off the mood that threatened to engulf him and began extolling the carefree virtues of Serona.

Halle returned from the kitchen carrying three large glasses and a bottle of brandy. We toasted Serona. Zephyr told a story about a drunken pilot spitting cherrystones at the window of a lighthouse and, by gentle increments, the evening pleasantly eased into night.

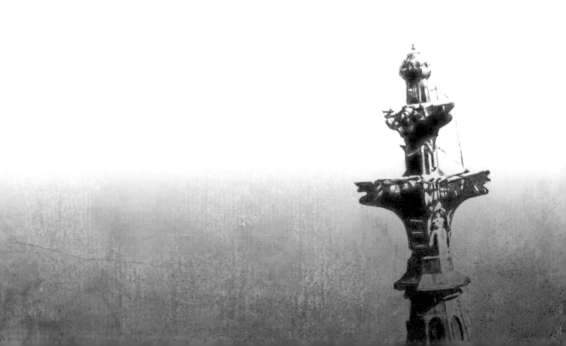

11

She woke not knowing where she was. She sat up in the strange bed and looked around the room . . .

. . . She had run away to avoid the trap that Marco represented. She had come to look for Felix Bulerias to see if he would teach her how to dance beyond mere selfish pleasure. Instead, she had let herself become distracted by a man who showed her passion but was essentially egotistical. She needed to stay away from Boreos. She needed to redirect herself toward her goal. If Felix Bulerias was not to be found immediately, then for the time being she would need another method of learning. As Sirocco had pointed out, she must listen more intently to the rhythm beneath her feet.

Rain was falling steadily and that made Ana think of Halle's roof garden. Earlier that evening, Halle had taken her up there. "Feel free to use it anytime," Halle had said with her customary generosity. She probably hadn't meant three in the morning, but the urge was overwhelming.

Ana walked softly up the small flight of stairs that led to the roof. Opening the door to the warm, damp air felt exhilarating. She stood by the low wall that edged the roof and looked down at the glistening street. She thought she

could hear a faint music drifting in on the breeze. It was tantalizing. One second she was sure the sound was real and the next she thought it must be in her head. She stepped back from the perimeter and tried to follow the thread of the elusive refrain. For some reason Zephyr and his swirling kite came into her mind. Moving her arms and shoulders slowly, she let her swaying torso guide her hips, her legs, and then her feet. No longer governed by her mind, her feet steered her body. The tune was not mournful, though it was melancholy. Never speeding, it gyrated within its solitude. She traced it around and around the rooftop until eventually the rain began to fall more violently and she could no longer hear any music, just water drops striking the tiles. Their staccato beat broke her hypnotic swirl, and she began to dance to the drum of the rain. Faster and faster she whirled until she lifted her face to the clouds and laughed out of sheer pleasure. With the stronger rain came a drop in the temperature and soon she was shivering. But this, her fresh beginning, had brought her relief, and she returned to her room, dried herself off, and climbed back into the cocoon of her new bed. She smiled as she slept.

Mr. Hamattan was waiting by the bench. He bowed and they began their second lesson. There was no improvement in his lamentable playing and Ana was beginning to despair that she was failing as a teacher. She was about to say something when a large group of children dressed in yellow and black blazers arrived in the park and encircled them. Some began playing noisily nearby, while others simply sat close and watched the two adults. Mr. Hamattan took the incursion in stride, but Ana found it impossible to concentrate, so she suggested they move. As much as she loved children, coaching Mr. Hamattan was

hard enough without being surrounded by a swarm of bumblebees. They transferred to the other side of the park, but children buzzed after them. Seeing her growing distraction, Mr. Hamattan suggested that they repair to the quiet of his boat, which he said was moored close by. Ana readily agreed and they fled to the waterfront.

Mr. Hamattan's boat turned out to be a ship, an old sea clipper that had been both lavishly and lovingly preserved. The *Mistral* was large, three masted, and very sleek.

They sat in a small, quiet side cabin surrounded by walls adorned with exquisite musical instruments. Sadly, the tranquility didn't improve Mr. Hamattan's playing, but that was to be expected. His clumsiness was starting to become something of a shared joke. They ended their lesson as before, with him telling her how much he'd learned.

He asked her if she would mind waiting a few seconds while he found something. During the time he was away, Ana ran her hands over the polished cherrywood that lined the cabin. She liked this ship. It felt familiar, a place she understood better than bricks and stone. She wondered who looked after Mr. Hamattan. Was it the crew, or did he have other staff? There was neither sight nor sound of another soul on board.

When he returned, he handed her a silk pouch containing her weekly fee. Then he asked if she'd like to see the rest of the ship. She nodded enthusiastically.

The tour of his traveling home started with the upper deck and ended in the lowest reaches. This final room he described as his concert hall. It was a

soundproof cabin containing a series of channels that ran up and down the floor. "These canals," he said proudly, "are the means by which I play my own instruments."

Ana had no inkling of what he was talking about. She looked around the rest of the room for a clue. All she could see was a wall of small cupboards, with doors marked with symbols from a language she didn't recognize.

"Pick one," he said.

She chose at random. He opened the cupboard she'd indicated and took out an oblong wooden box with pipes sprouting from all angles. He slipped the box into a set of grooves on the canal's wall and it dropped down into the water. Then he went over to a paddle wheel at the far end of the room. He released a catch and the wheel started to turn, forcing water around the canal's convolutions.

When the water reached the box, it began to emit a series of melodic notes. The pipes had been staggered so that each note was played without overlapping and without repeating the sequence. The effect was miraculous. She didn't know whether she was listening to a composition or an act of nature.

"It's wonderful!" Ana was utterly entranced. "Can I hear more?"

"I'm so pleased you appreciate my toy," Mr. Hamattan said, slightly shyly. "And I would love to entertain you further. But the vibrations will continue to circulate throughout the room. It will, alas, inhibit the clarity of any other aquatic instrument for an hour or so. If you come again, I shall gladly play you another one of the water pipes." His face glowed with a simple pleasure.

They returned to the upper deck and he saw her ashore. "Would you care to

conduct our next lesson in the park? Or do you prefer to come back here?" he asked.

"Are you sure you want to continue?" inquired Ana. "I don't seem to be doing well as a teacher."

"Nonsense," he objected. "It is I who am failing as a pupil! I shall practice. Next time I shall have improved."

Ana smiled at his earnestness and promised to return to the *Mistral* later in the week.

12

Halle handed me a bunch of keys, saying, "You should use the restaurant."

"How do you mean?" I asked, coming out of my early-morning musings.

"If you're turning down Boreos's offer of the weaving studio, then you'll need somewhere to practice your dancing. You should take advantage of the Carta Rosa. Unless, that is, you want to continue to dance on the roof."

She could see my surprise. "Light-footed as you are, it's directly over my bedroom."

"I'm so sorry," I said. "I had no idea."

"To tell the truth, it made me feel very cozy knowing that I was tucked up in bed while you were out there, bouncing around in the rain. There's no one in the restaurant in the mornings, so all you have to do is push back the tables and chairs and you'll have all the space you need."

"What if Junto finds out?" Though he was small, he made me nervous. I could never tell what he was thinking, and the last thing I wanted to do was to get in his bad books.

"Don't worry about Junto. Just tell him I said it was all right."

I looked at her curiously. "But he's your boss."

She smiled. "Well, he is and he isn't. Anyway, he's hopelessly in love with me."

I sat straighter in my seat, knocking the table with my knee and almost spilling my coffee.

"Are you kidding me?" But I could see she wasn't. "He seems too . . . well, too serious to be in love with anyone."

"He is awfully serious, isn't he?" she said, frowning. "He's always asking me to marry him. As if I haven't been married more than enough already."

"I'm stunned. Are we talking about the same Junto? The man who doesn't blink unless he has something in his eye?"

"That's the one." She was savoring her revelation.

"So, is he or isn't he your boss?"

"Mmm, sort of," Halle folded her hands and rested them carefully on the deep red tablecloth. "I suppose I should have told you, Ana. I own the Carta Rosa and, strictly speaking, he works for me."

I choked on my drink. I could barely speak. Finally I croaked, "You own the Carta Rosa? How come nobody warned me?"

"They don't know," said Halle. "None of the staff, that is. Only Junto. I don't like to make a big thing about it. My father left it to me at the same time that he left my brother this house. I don't want anyone to find out, Ana. I'd rather we keep it a secret between you and me. And, please, don't let on to Junto. It's important to him that he be seen as the one in charge."

As I walked to the restaurant I tried to absorb the implications of Halle's confession. Junto was Halle's boss, but she employed him. So if Halle had told

me I could use the Carta Rosa as a dance floor, and if Junto didn't tell me I couldn't, then I didn't need to worry.

The place was quiet. I'd never seen it empty before. I took my jacket off, and pushed twenty or so chairs and six of the tables against the wall, making sure I had ample room to move. I had an hour till the lunch shift arrived and I wanted to make the most of the time.

There was a large ornate radio behind the bar that was sometimes used when the musicians weren't playing. Having turned it on and waited for it to warm up, I twisted the center dial this way and that. Since there was no electricity at home in the valley, I had only recently been introduced to the art of tuning. I rejected half a dozen stations until I came to one that was broadcasting a piano and guitar concert. The music was quite slow and stirring—a little austere for the morning, but it sufficed. I kicked off my shoes, slid my toes over the pitted and cracked tiles to accustom them to the fragmented surface, and began.

When I practice I do not think of particular movements. I am not trying to follow any prescribed choreography, or even interpret the music. Nor am I simply loosening my muscles. I am, first and foremost, trying to stop my mind from predetermining my movements. Of course, my body has memories—paths of previous arm, shoulder, and leg motions—patterns that have been ingrained within me. But the possibilities are infinite and I rarely feel like I'm repeating myself.

I danced for a while, sometimes moving freely, occasionally becoming stranded when the piano lingered amongst the high notes. Then the music

took on another dimension. In the background a drummer started to beat out a meter with soft hands. I silently thanked this new musician for giving me a steady rhythm to follow.

I stopped abruptly. The drumming was not coming from the radio. I looked around and then over to a window alcove, where Sirocco was sitting cross-legged on an eye-level ledge, a pair of tabla-like drums wedged between his knees. He waved to me.

"Why are you here?" I blurted, feeling both foolish and vulnerable. I hated knowing that I'd been secretly observed.

"You are letting your head roll too much," he said, ignoring my question.

"How did you get in?" I said, unwilling to be deflected.

"The same way as you. Through the door."

Stupidly, I must have left it unlocked. But it was still odd—the way he had just appeared. "I didn't see you arrive."

"Your eyes were closed." He was coming toward me, a look of amusement on his face. It struck me how quietly he crossed the ground. For a second, I believed he was going to show me how he thought it should be done. But he just said, "Here, let me help you put everything back before the others start arriving."

I glanced up at the clock. It was later than I thought. As we replaced the tables my agitation subsided. I couldn't blame him for coming in. After all, it was I who had forgotten to lock the door.

"Where did the drums come from?" I asked in a conciliatory tone.

"They were under the stage. Someone must have left without them."

"I didn't know you played." Again my picture of him was changing.

"Why would you?" he laughed. "You move well for someone so young. When you allow the rhythms to take you, you will be even better."

I let go of the tablecloth I'd been straightening, "What particular rhythms are you talking about?" I asked, not really sure if I should be listening to his advice or telling him to mind his own business.

He was about to reply but his answer was cut short by the arrival of Junto. "Where's Halle?" he demanded.

I held up the keys. "She asked me to open up for her."

For a fraction of a second he looked concerned. "Is she all right?"

"She's fine," I said. "Just had a few things to do."

Junto squinted at Sirocco as if there were something he didn't quite understand. He ran his eyes over the room and fixed his attention on the tables we'd just replaced, "Twelve and seventeen are short of chairs. Please address that." Then, starting to move away, he said to himself, "I must deal with the roster."

Once he'd disappeared into his office, I started to giggle. "He's so stiff," I said.

Sirocco responded gravely, "His solitude must be a heavy burden." And then with a wink he tossed my shoes over to me.

I'd been back in the house no more than two minutes when a voice behind me commanded, "Let's go."

"Pardon?" I said, turning abruptly.

"We need to leave now." Zephyr was leaning on the door frame of my room. He was wearing his leather flying jacket and a cheerful smile.

"Leave for where? How? Why?" I asked, bemused by his assertion.

"Surely I told you. Today's the day we are required to visit the fairground."

"Zephyr, what are you talking about? This is the first I've heard of a fair or of our going anywhere." I was pretty sure that the notion had only just jumped into Zephyr's head.

"Are you saying that a daredevil young woman like yourself has no interest in going to the fair?"

"I didn't say that," I said, excited by the possibility of fulfilling a childhood dream. "Give me five minutes to change."

"Excellent!" he said, showing no sign of vacating the doorway.

"That means without you watching me," I told him, kicking the door shut.

"Where's the fair?" I asked as we stood on the corner of our street a few minutes later.

"At the far end of Nunez. You know, that long avenue with all those sycamore trees that leads right out of the city. We can take the tram to the terminus and walk the rest of the way. It's not far."

When I was eleven, Francesca, the girl who sat next to me in school, had infinite ways of making me laugh. She would pull faces, tell jokes, and make outrageous noises. The more I tried to be sensible, the more she seemed able to make nonsense of everything around us. Zephyr had that same ability. Being in his company was so utterly different from being with Boreos. I didn't have to try or even think. I could relax and forget about being grown up. He

had the uncanny knack of spotting the ridiculous. As we sat on the tram he pointed out a tiny man crossing the road with two dogs. He had one under each arm. The dogs were facing opposite ways and each was trying to bite the other's tail. By the time we reached the end of the tram ride, my ribs were aching from laughter.

As he had predicted, the walk from the terminus to the fairground was short and the crowd swept us along. I looked over at his profile. He wasn't overpoweringly handsome like Boreos, but he exuded an almost touchable vitality. I briefly indulged in a vision of what might have happened if I hadn't kicked the door shut earlier.

Zephyr asked what I wanted to try first. I was nervous about the fast, swirling machines, their wound-up music and flashing lights, so I opted for the white tents that housed more gentle pursuits like archery, hoops, and coconut shies. It was this last stall that most fascinated me. I'd never even touched a coconut and I wanted one very badly. I flung each of my wooden balls with as much might as I could muster and twice I hit coconuts full on, only to see the ball ricochet off. I turned to Zephyr and threw my arms up in despair. "I think they're glued to their stands," I horse-whispered.

"That's more than possible." Zephyr removed his coat with a glint in his eye. Paying the young red-faced attendant for a new pail of balls, Zephyr weighed one of the spheres carefully. Then he let fly. I could not believe the velocity his slim frame was able to generate. For a fraction of a second the ball seemed too high, but it swung and dipped at the last moment and hit its target so violently that the coconut completely shattered. Zephyr turned toward the

now even redder-faced attendant and shot him a withering stare. The youth, who clearly wanted no argument with anyone who could throw a ball that hard, immediately held out a fresh, glue-free, coconut. "I think," said Zephyr, "it belongs to the lady."

I confess I liked being called a lady. I clutched tight my coconut and declared that I was ready for something more arduous.

For the next two hours we rode in little cars that bumped into one another; I had my stomach turned inside out on a giant clockwork whale; we saw ourselves squashed and elongated in curved mirrors; we watched bearded ladies, five-legged sheep, and muscle-bound strong men. I lost myself in another world.

Finally Zephyr asked me how brave I was feeling. "Oh, brave as brave can be!" I said, heady with all the fun and gaiety.

"Then let's try the Catapult."

I should have known. As it was, I didn't understand what was about to happen until it was too late to back out.

The Catapult was off to one side of the fairground and took up an area the length of two fields. A small contraption—Zephyr called it a sling-glider—sat on top of a tall wooden framework. "I thought you might like to come on a short flight with me." He settled himself down in the cockpit beside me. "Just so that you can have a taste of what I do."

I must have been slow witted because it really didn't dawn on me what was about to happen. Once we were seated, two men looped a horizontal wire from what looked like a giant crossbow over a hook on the glider's

underbelly. I wasn't able to see properly from where we were but I could hear a winch being strained. Zephyr told me to hold on tight to the rail. He signaled to someone. There was a grating noise, and a wild whir, and then we were *flung* into the air. I instinctively dropped my coconut onto the floor and gripped the railing for all I was worth. In the blink of an eye we were at least fifty feet off the ground. I could feel the air rushing past my face. And then we slowly started to arc back down. There was a large net waiting for us at the far end of the field and the glider landed as neatly as a gull touching down on a wave. I gulped, and then I turned and started hitting Zephyr as hard as I could. "How could you?! You didn't even warn me! I told you I'd never go in a plane and you put me through *that*." Despite my blows, he was laughing so hard he was close to crying.

When we were back on solid ground, I continued to berate him. But then I grabbed him by the shirt collar, pulled his head down toward me, and kissed him on the mouth. "Thank you. That was the most exciting thing I've ever done in my life. Don't ever do anything like that to me again."

He looked at me and said, "I'm sorry. But I knew you would like it and it was the only way. When I've built my new plane, will you come for a spin with me?"

"I certainly will not," I replied, knowing full well that I would.

13

"Ana." Halle's voice drifted up the stairs. "There's a messenger here for you."

Thinking it was the florist's son bringing yet more flowers from Boreos, Ana took her time coming down. When she stepped into the living room she was surprised to see a smart, young almond-eyed sailor, dressed in a crisp white uniform. He held his cap in one hand and an envelope in the other. "Miss Dijjo, Mr. Hamattan asks that you kindly read this." He handed her an envelope.

Ana opened it with the paper knife passed to her by Halle. The note read:

Dear Ana,

I have just received information that Dr. Bulerias is on the island of Anangion. He has agreed to address a small meeting at the salon of the Centro Artistico there on the subject of the cante.

As fortune would have it, I am about to depart for Limus, which, as you may know, is less than half a day's sail from Anangion. If you so wish, I would happily transport you to and from Anangion so

that you might meet with Dr. Bulerias. The *Mistral* will be setting sail by this afternoon's tide. The round trip will take no more than three days.

My ship's officer will await your response and, should you choose to sail with us, will return to escort you at 12:30 p.m.

With kind regards,

Giba Hamattan

Ana barely knew what to make of this most unexpected missive. She read it again and then handed the letter to Halle, who took it in at a glance then passed it back, "I presume you intend to go."

Ana replied, "Yes. I must. But what about the restaurant?"

"Don't let that stop you. Zo will cover for you. After that business with the drunks, she thinks the sun shines from your ears."

"That's sweet of her." Ana was quickly scribbling a note of acceptance. She handed it to the ship's officer. "Don't worry about coming back for me. I can easily get myself to the dock."

On her way up the stairs, she passed Zephyr.

"In a rush?" he asked.

Ana told him about the message and apologized for the fact that she wouldn't be able to go to the theatre that night, as they'd previously planned. Zephyr's eyes narrowed, but he turned them well away from Ana. "Absolutely," he said. "You can't miss such an opportunity. Should I book seats for later in the week instead?"

"Yes, please," yelled Ana, who was already in her room grabbing a bundle of clothes for the voyage.

She arrived at the *Mistral* rosy cheeked and a little breathless at the prospect of not just finding Felix Bulerias at last but also going on her first sea voyage. Mr. Hamattan came down from the wheel deck and greeted her. "I've had the captain's cabin made available for you."

"What about the captain?" she said, suddenly having doubts that she should be going anywhere on such a luxurious ship.

"He can have the second officer's cabin."

"So, does that mean the second officer will be demoted to the third officer's cabin?"

Seeing her concern, Mr. Hamattan responded, "Yes. If we run out of bunks we will simply throw someone overboard."

She was pleased to see that Mr. Hamattan had a sense of humor.

Ana had spent the first few hours of the twenty-three-hour voyage doing very little. Initially, she felt a little wobbly as she promenaded the deck. But as she stood at the railing watching the outline of Serona recede, she slowly became accustomed to the rhythm of the waves through the ship's boards.

Mr. Hamattan was busy until the evening meal. When he finally joined her at the table, he was gracious and considerably more confident in manner than during their past encounters. Ana politely alluded to his mastery of the vessel and he replied that he always felt comfortable when the *Mistral* was on the

open sea. Over dinner of lime-drenched lobster he spoke about water and its economic importance. Ana had never thought of water as a commodity. When the table was cleared, Mr. Hamattan announced that, regretfully, he must continue with figures he was preparing for his meeting about the aqueduct on Limus.

The following morning, Mr. Hamattan appeared for breakfast around eleven. He seemed to be preoccupied, but that didn't stop him from taking Ana to the upper deck to watch their arrival in Anangion. Once they were docked, he escorted her down the gangplank. He left behind the officer who had delivered the message to Halle's house, insisting that, this time, Ana accept the young man as her escort. As the *Mistral* pulled away Mr. Hamattan called down to confirm that he would return the same time the following day.

Now that she was so close to meeting the man she had been seeking, the man she was certain would become her teacher, Ana was hit by an unexpected wave of anxiety. Excitement and apprehension had been with her for the whole journey, but this new emotion seemed uncalled for, until she recognized it as the same nervous flutter she had felt ten years before, the last time she had seen Felix. She remembered the silence he had commanded. Even her father seemed awed by this man. No more than a child, she had stepped into the arc of firelight, wondering if he could see or hear the telltale shivering of the tiny bells attached to her cuffs. But when she was finished, Felix had looked up at her grandfather with a face dampened by tears.

The young sailor introduced himself as Lieutenant Pascal.

"What's your first name?" Ana asked.

"David, miss."

"My name is Ana and we will be on first-name terms. Yes?"

"Yes, miss."

Ana sighed. "David, do you know where the Centro Artistico is housed?"

"Yes, miss, it's a café not five minutes from the quay."

"This quay?"

"Yes, miss."

"Then maybe we should head there."

"Yes, miss."

There was only one street in the town of Anangion and it was not difficult to locate the café in question. On its window, a large poster for the Festival of Cante had been freshly pasted over the collaged fragments that had once been advertisements for everything from Isthmus sherry to an evening with Sebastian Faro and his nine-string guitar. The inside was similar to that of many cafés in Serona. The only thing that set it apart was the shiny futurist coffee machine that seemed to take up most of the counter. Ana asked the laconic barman about Felix Bulerias and was told that he would be there around seven that evening.

"Miss." Her escort was sticking close to her elbow.

"Yes, David."

"Mr. Hamattan has registered you at the hotel. Would you like to go there now?" Ana lightly slapped her forehead. "Damn, I didn't bring my bag."

"Not to worry, miss. Mr. Hamattan sent it down just before we came ashore."

"He really does think of everything, doesn't he, David?"

"Oh, yes, miss. He does."

They had arrived in the hotel lobby and Ana decided that if she heard one more "Yes, miss," she would probably strangle poor David. So she packed him off to do some sightseeing and retreated to her hotel room.

Ana wasn't sure whether to arrive early at the Artistico to try to catch Felix Bulerias before things got under way or wait till afterward. In the end she decided that he might be more amenable to her request after the event. She got to the café around a quarter to seven, only to find the place already almost full. There were obviously more people interested in the cante than she had anticipated. Ana ordered a drink from a frazzled waiter, and when it eventually came she moved to the back of the room. Sipping the coarse white wine, she strained for some mental picture of Felix—she'd been barely nine the last time she'd seen him. Of course, her grandfather had told her all about his close friend. How Felix was part Capolan, part Andaluz, and how he had seen many places and been many things, including a monk and a bullfighter.

At five past seven a slim, gray-clad figure emerged from a side door and made his way to the center of the room. The crowd's babble hushed. Felix Bulerias wasn't a large man, but somehow, even in his advanced years, he seemed to overshadow those around him. Ana watched as her would-be master climbed onto his stool and settled himself. He did not hurry. He

looked carefully around at the faces, examining the degree of commitment in the room. And then in a sonorous, baked-earth voice, he began:

"We have gathered here this evening to share our profound commitment in that ancient and lustrous truth known as cante jondo.

"Friends, the forest has almost shed itself of memory and the artistic soul of our people is in jeopardy! A vulgar noise smudges the air of this proud and confused country. Every day, our songs and our dances are buried with the old men and women who carried them. I gaze into your earnest faces and ask myself, are we prepared to stand mute and watch the lyrical wealth that is our artistic heritage slide into the grave?"

He spoke of not just the Capolan but the Andaluz, the Romany, and the Felahmengu. He called them the fugitive peasants. He did not linger on the painful mistreatment of those who are earmarked to wander but, rather, he spoke of the dignity of their shared spirit and of the need to let duende guide the passage of their feet and the tremor of their voices. "Only then, only when a true artistic pride is reestablished, and our kinsfolk inherit their dignity, will the council of governments move to give political status to the vagabond tribes."

The room broke into applause. A spontaneous clapping that became a rhythmic wave. Shoulder to shoulder the crowd cheered and clapped harder. Ana was filled with admiration. Her voice joined with the others demanding more.

Felix set aside the stool and raised his arms. "I do not speak of hollow dreams. This is not an occasion for mere oration. Tonight you will bear witness to many forms of cante. All have their place. Let yourself be embraced." With that, he banged down his right heel and stepped back, leaving the stage open.

There were many that night who came forward. Some danced or sang from great sorrow, others, from exhilaration and love-fed desire.

Even though she knew much of the music, Ana found herself shaken by the singularity of the performances. And in retrospect the best, the most daunting, were not performances at all—they were personal and tribal histories dragged from the belly to the throat and ejected in a haunting guttural clarity.

Later, sitting on the low wall opposite the café, Ana watched the Artistico disgorge its clientele. Felix was one of the last to leave. She crossed the road as he was putting his coat on. "Excuse me," she began.

"Hello, Ana." Felix's tone was warm and friendly.

She was completely taken aback. "How did you know . . . " she stammered.

"You move like Ana. You speak with Ana's voice. You must be Ana." There was mirth in his tone.

"But you've not seen me since I was a child," she replied, forgetting the now redundant self-introduction that she had prepared. "Have I changed so little?"

They were standing in a pool of blue light thrown down by an ancient lamppost while Felix examined her more carefully. "You have become a young woman. But the bones and the grace are the same." He paused and then continued. "And besides, I was expecting you."

"What do you mean, you were expecting me?" asked Ana, wondering if perhaps Felix's gifts included clairvoyance.

"Your grandfather wrote to me. Told me that the last time he saw you, you were running into the forest to escape your wedding." Ana beamed with

pleasure. "Of course," continued Felix, "he wasn't sure exactly when you'd come looking for me, but he said that I should keep an eye open for you." A gust of cool wind passed down the street. "Let's go back inside. I'll buy you a drink, and you can tell me how you found your way to Anangion."

As they reentered the café Ana asked about her grandfather. Had he sent any news? Felix assured her everything was all right and that he'd tell her what he knew later. But first he wanted to hear what had happened to her.

It took Ana about half an hour to relate her story. (Later, thinking back, she noted how much she didn't mention.) She ended her tale with "...and I hoped you'd let me become your pupil."

Felix's expression changed. He was immediately grave. "I haven't taught anyone for a long time. Why would I want to burden myself at this late stage of my life?"

"I wouldn't be a burden," Ana said, trying to sound like she understood his concern. "I would be the most hardworking and respectful of students. And because it is for the Capolan more than it is for me."

He looked suddenly very weary. "Fetch me the guitar from behind the counter."

She did so without question. He took it, tuned it for a few moments, and said, "The middle of the floor, please."

Ana did as he bid, turned, and faced him. Without ceremony he began to play, and without thought (she dared not clutter her mind) Ana danced.

It was over in five minutes. She didn't think she'd done badly. In fact, given the circumstances she thought she'd danced quite well. She came back and sat

down at the table again. Felix leaned the guitar against a chair and looked at her. "I can't," he said in a quiet voice.

"You can't?" Ana echoed, not fully comprehending.

"I cannot teach you. There are other influences involved here."

She looked at him, confused. "What do you mean other influences?"

"It is hard to say exactly, but I see you turning in the heart of a circle. I am only an old man. I cannot compete with your partners."

"What partners?" She felt mystified, desperation starting to rise in her chest. "I dance alone! Always!"

"We cannot always see those who partner us," he said, almost to himself. "No, I cannot compete. I'm sorry, Ana. The spirit flows through you with unerring vitality and I'm certain that ultimately you will succeed beyond your dreams, but for now you must counsel yourself. There is nothing I can impart to you that life and those that swirl above are not already doing, to bring the cante forth."

"But I . . . " she faltered, looking around the nearly empty room as if to find support for her case, "I have no one to help me. I don't understand these things you are saying to me. I can't teach myself. I don't know what I'm doing."

"You know enough for now."

This was not working out the way Ana had expected. Felix was supposed to say yes and justify her flight from her home.

She tried again. "But Grandfather told me you knew more than anyone else about our people's ways. You understand what's happening to them. If I don't

learn how to dance, then who will guide them? We cannot leave them in that place to shrivel and die."

"You already dance well." He was watching her carefully.

"Please don't toy with me. I am not talking about dancing for the love of it."

"Then maybe you should," he replied.

"I want you to show me how to perform that one dance that will lead them back onto their road."

"You ask the impossible. Customs, stories, songs. Those I know. On what ground Ana should dance for her tribe and under what sky she will open her heart—only you will discover."

Ana was near tears. She didn't want to be told these things.

"Can you give me nothing?" she asked fiercely, trying to hold on to what remained of her pride.

"I can give you my blessing," replied Felix with compassion.

Ana's voice started to crack. "I just don't understand. I have come so far."

Felix arose. "I know. And you have far to go. Be strong." He kissed her on both cheeks. And then he turned and walked out of the Centro Artistico.

Ana watched him leave. She remained seated. She had no idea what to do next.

"Miss? Are you ready to leave now?" Her faithful escort must have been waiting in the wings all evening.

Ana focused as best she could on the sweet-natured boy. "Yes, David. You can take me back to the hotel. Thank you."

Mr. Hamattan noticed the disappointment still hovering around the corners of Ana's mouth as she ascended the gangplank the next day. He ushered her aboard the *Mistral* and instructed his staff to attend to her needs. He waited for an hour and then knocked on her cabin door. "May I offer you a late lunch and some distracting conversation, my dear?" he asked soothingly.

Ana thanked him for his kindness. Up until that moment she'd tended to think of him as being old, but now, comparing him to Felix, she could see he was probably only in his late fifties or early sixties. She felt a bit guilty that she'd so often looked on him as an awkward student rather than the competent and successful man he clearly was. She took his arm and allowed herself to be steered to the dining room. Passing a porthole she noticed that the ship was making good headway even though the wind was against them.

Once the steward had ladled the asparagus soup from a half-moon tureen, Mr. Hamattan spoke. "I gather from your low spirits that Dr. Bulerias didn't respond to your request in the way you wished."

Ana, who had had time to digest most of what had been said to her the night before, replied, "No. He told me that he could not be my teacher. I resisted his words, but I'm obliged to accept them. I'd set my heart on having someone who would guide me, and now I find that I am thrown back in charge of my own education."

"Ah!" said Mr. Hamattan, "You must feel very isolated, my dear."

"Yes," replied Ana, relieved to be understood. "I do."

Mr. Hamattan's understanding manner continued throughout the day. He seemed to grasp and sympathize remarkably with Ana's plight. Their lunch

stretched well into the afternoon, and when it was over Mr. Hamattan took her again to the room where he kept the water music boxes. She was, if possible, even more entranced by the music from his creations. She wondered how this man who obviously had such a well-tuned ear could be so inept when it came to playing wind instruments.

They sat in Mr. Hamattan's cabin, ensconced in large leather armchairs, their legs stretched out on padded stools. As was the custom on the *Mistral*, both went barefoot. They drank coffee and talked of musical composition and Ana felt blissfully spoiled. Nothing could assuage her deep disappointment at being turned down by Felix. But at least Mr. Hamattan was proving to her that she wasn't completely alone.

When the steward removed their empty cups, Mr. Hamattan whispered a quiet command that Ana wasn't able to catch. The officer returned shortly with a small stone bottle. Mr. Hamattan uncorked it and said, "May I?"

Ana thought it must be some kind of after-dinner drink, but Mr. Hamattan poured out a few drops of the amber liquid onto the palms of his hands. Then he knelt before her and began to massage one of her feet.

Being a dancer, Ana had had her feet rubbed before, but only by the work-roughened hands of her mother. Mr. Hamattan used his strong, manicured hands in a very different way. His thumbs and knuckles kneaded her tight arches, his fingers stretched and exercised her toes. He pressed in, but never too hard. He stroked, but not so gently that it tickled. He sought out and worked away the knots across the landscape of her soles. The resistance housed in her feet eased—and with it so did the tension throughout her body. She was

too tired to think anymore. Her eyes closed. First her legs, then her belly felt as if they were being cleansed. It was as if the sea were passing through her, flushing away all of the demands and obligations that had been placed on her. Ana had a glimpse of life without futile fear and duty, and a weight began to move from her chest, allowing her lungs to open and close with ease. She could feel the water seeping through her skin, the droplets turning into tiny silver coins that jingled as she moved. A wave of longing broke over her, and in her mind she began to dance; those who watched her were transfixed, linked by their desire and compassion for one another.

When he finally stopped to cover her feet with a warm towel she slowly resurfaced. Mr. Hamattan's behavior had been the soul of propriety. He had taken no advantage of whatever arousal he had seen or felt in her. More than ever, she knew she could always rely on him.

14

Cecile was a quiet girl with fair, crinkly hair and a turned-up nose who seemed to have difficulty keeping the front of her blouse dry. She had been working at the Carta Rosa only a short while when, one morning, she turned up with a baby in her arms and an apologetic expression on her face. I had no idea she had a child.

We all gathered around her and fussed over the baby. He was getting his cheeks stroked and his head nuzzled, and I have to admit I even slipped off one of his woolen boots so that I could rub his tiny pink toes. At the campsite I was forever on all fours playing with my cousins' and friends' children. But since coming to Serona, I'd had almost no contact with children, apart from the older ones who came into the restaurant with their parents at lunch. And, of course, the bees in the park. I hadn't realized how much I missed the babies, with their no-tooth smiles and infectious giggles. I looked over at Halle to see if she was joining in the infant worship, but she wasn't looking at the baby: she was watching us, all of us women, with a half smile on her lips. It was as if she were viewing us from above, interested in the whole scene, not just the child we were adoring.

I almost expected the baby to become overwhelmed by the strange hands and cooing voices, but he seemed to bask in the attention, playing his audience to the full.

Cecile was sheepishly explaining, "My sister usually looks after Joseph when I'm working, but today she had to take her youngest to the doctor's. She'll be by to pick up Joseph in an hour or so. I'm not sure what to do about him till then. If I put him down he'll start crying. As long as I'm holding him he's as good as gold. Maybe I could lay tables with my free hand?"

Zo piped in eagerly, "We could take turns."

Cecile wasn't sure. "He usually cries if someone else picks him up."

"Let me try," begged Matilde.

As his mother had predicted, Joseph announced his displeasure the second he was within Matilde's grasp. His cheeks turned beetroot, and he let out a howl that could have broken a wineglass.

"Explain to me why there is a screaming baby in the dining area." Junto had appeared out of nowhere and was standing in the middle of our ranks. He was dressed in his smartest gray suit, and his face was a mask of uncompromising severity. He scowled at Joseph and then turned to Cecile, "Yours?"

Cecile nodded, worriedly.

"Is this a nursery," Junto's voice was raised in exasperation, "or is it a restaurant? Do you imagine the wail of a screeching baby will aid our customers' digestion?" He was so outraged that I could picture him snatching the child up and throwing him over his shoulder, just like the plate he'd tossed at me on my first day at the restaurant.

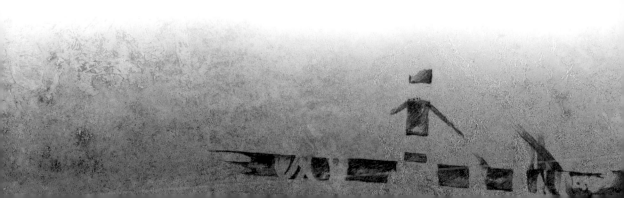

We all started to speak at once, attempting to explain the situation and defending Joseph. I was in the midst of saying that the baby would be quiet if he were just returned to his mother when I noticed that Joseph was already silent. In fact, he hadn't let out a peep since Junto had appeared. The child was staring at the man with total fascination, and Junto, in turn, inexplicably found himself mesmerized by the baby's big black eyes. I believe we all must have seen it at the same moment, because the room stilled as we stood and watched the strange spectacle of Junto falling under the baby's spell.

Compelled, Junto held out his arms. Matilde checked to get Cecile's approval, and passed Joseph over to her boss. Junto took the boy awkwardly. He obviously hadn't held many babies before and he wasn't sure what to do with the legs and where to place his noncradling hand. But that didn't matter to Joseph—not one whit. He just wanted to be as close as possible to his adopted protector.

The transformation in Junto's countenance was so remarkable that we simply stared in wonderment. There was a man, known to be as cold as a winter river, acting as if he were the mother of nature. Over his shoulder I could see the expression on Halle's face. She was no longer a distant observer. She was watching Junto with different eyes, and I could tell he had just risen angelically in her estimation.

After a few moments Junto looked up as if to say, Are you all still here? We took the hint and dispersed, leaving only Cecile hovering nearby to make certain her son didn't suddenly change his mind about the company he was keeping.

Cecile's sister arrived after about an hour, and Junto reluctantly gave Joseph to his mother, who, in turn, handed the boy on to his aunt. Most of the waitresses were watching the handover, and I imagine all of us probably had the same small ache in their hearts as I did.

Around seven o'clock, one of the customers paid for his meal with a 500m banknote. Junto was adamant that he personally inspect all large notes before they were accepted. I took the brown-and-green bill through to his office, tapped lightly on the door, and twisted the knob. It was locked. From inside I heard rustling and Halle's muffled voice whispering, "Hush!"

I stepped back, my hand still on the smooth, rounded brass knob. I let go, turned, and looked up at the light coming through the glass ceiling and the birds flying from beam to beam. I shook my head—I knew nothing about anything!

I got Zo to check the banknote to make certain that it wasn't fake and gave the customer his change. After he left, I brushed the tablecloth and put out clean knives and forks, a bread plate, and a fresh linen serviette. When I passed the table a few minutes later, it was occupied by two new customers. A delicately pretty young woman, with a slim figure and a cap of fashionably short hair, was seated next to her handsome companion—Boreos!

I tried to block all feeling, but I couldn't. A flash of jealousy flew through me. How ridiculous! How stupid! I'd been avoiding Boreos for three weeks, ignoring his notes and his flowers, hoping to make it clear to him that I had other priorities. Yet as soon as I saw him with another woman, I wanted to

pour a pitcher of water over her head. Worse still, when I met Boreos's eye, I worried that he'd been able to read my thoughts. Had he asked for a table in my quadrant? Damn it, how dare he try to trick me into reacting? I was determined not to give him the satisfaction, so I greeted them both politely, handed them the menus, and asked if they would like a drink.

Boreos turned to the young woman and said, "Sophie, what would you like?" The combination of authority and allure was all too familiar, and I saw the girl flush when he spoke to her. I immediately felt guilty for my first impression of her. She was infatuated, that much was clear. It wasn't her fault that Boreos had chosen her to play his game.

Then again, perhaps it wasn't a game. She was very comely. Perhaps Boreos had simply decided to put me out of his mind.

Sophie timidly asked for a cocktail, as if she might be turned down. I guessed she was no more than seventeen or eighteen. Boreos rubbed his chin while he considered his order. "I'll have a schnapps, please, Ana." With my name in the air, Sophie looked up, not quite sure what the familiarity implied. I smiled at her reassuringly. No point in her being made to feel uncomfortable.

While ordering the drinks from the bar, I considered getting one of the other girls to serve the table, but I was too proud to allow him the victory. By then Halle was back on the floor and, seeing Boreos and Sophie, she sidled over to me and said, "That's a bit obvious, isn't it? Does he really think he can get you back that way?"

When I didn't reply, she took me firmly by the arm, "Don't even consider it. If you wouldn't take him then, you'd be a fool to try and get him back now."

Halle was right. I looked over again at the two of them. Sophie was chatting away, casting winsome glances at her cavalier. She seemed both thrilled and incredulous to find herself with the most attractive man in the house. I just hoped Boreos wasn't using her as a pawn, as Halle seemed to think.

Halfway through their meal, Sophie went to the cloakroom. While she was gone Boreos called me over to the table. "How are you, Ana?"

"I'm well, thank you," I replied, being careful to sound neither friendly nor hostile. "And you?"

He ignored my question. "You haven't responded to my messages." There was a slight touch of petulance in his voice.

"No, I've been busy."

"I heard," he said wryly. "Did you enjoy your sea voyage?"

"It seems you know all of my movements," I replied more coldly.

"Nowhere near all, I assure you. Speaking of travels, I was hoping I could talk you into coming on another picnic."

"I think not," I said quickly. I could see Sophie starting to cross the floor on her way back to the table.

He followed my eyes. "Oh, don't mind Sophie. She's just a friend."

"I hope you treat her as a friend should be treated," I said, sounding slightly more shrewish than I intended.

Boreos spread out his hands and shrugged, as if to say, "What do you expect? I'm only a man." I turned and walked away before Sophie could reach us.

Why was his self-confidence so infuriating and so appealing at the same time?

I continued to serve them throughout the evening, but I spoke no more than

I had to. I could tell that Boreos was becoming irritated with me and Sophie was having to work ever harder to keep his attention. When they finally left, I noticed Sophie teeter a little on her slim heels and then lean on Boreos's arm for support. It's true that I wished she would twist her ankle on the cobbles outside, although it was as much to protect her as it was to rob Boreos of his conquest. But what was the point? I could not control the destiny of another. I let them go. When I cleared up I saw that he'd flung me an outrageously large tip.

Walking home, Halle said to me, "Quite a night."

"For both of us," I replied. "Dare I ask if that was you with Junto in his office this evening?"

"I cannot tell a lie," she laughed. "I was touched by the way he took to the baby and it seemed only right to reward him."

"And did you manage to reward yourself at the same time?" I queried.

"Yes, I did. And I was reminded how much pleasure a little intimacy can give."

Halle seemed to be so uncomplicated in her attitude toward men. I wished I could follow her lead. "All the girls were really surprised by the way Junto took to Joseph—and Joseph to Junto," I said, deciding not to press Halle for any details of her encounter.

"He's a kindhearted man. He just doesn't know how to run the place unless he pretends to be tough."

"Will you take him as your lover?" I asked.

"I'm not sure," said Halle, as if considering the possibility for the first time. She turned to me. "But what about you? Has Boreos tempted you again? Maybe you can save young Sophie from a fate worse than death."

"I think it's a bit too late for that," I said, glancing at my watch. "No. I'm clear about that. I don't dislike him. But he's too dangerous to get close to. Boreos loves Boreos and that doesn't leave room for anyone else."

"He'll be disappointed," reflected Halle.

"I'm sure he'll cope," I responded dryly.

At least when it came to Boreos, I seemed to have made my decision.

15

Ana was acutely aware that a week had passed since her return from seeing Felix, and during that time she hadn't once been to the restaurant to dance. She believed that Felix had had her best interests at heart when he rejected her, but she felt wounded. She'd set her heart on becoming his pupil. Without his guidance, or even the hope of it, she felt lost.

But Ana hated failing herself almost as much as she hated failing others. Now, in the predawn gloom, she dressed slowly, building her determination. She would show him, prove him wrong. She had to start her dancing routine again. It was early and, not wishing to make noise in the kitchen, Ana grabbed a piece of bread, wiped butter and jam over it, and walked briskly to the Carta Rosa.

She cleared the tables and chairs from the floor and, as Sirocco hadn't yet arrived, turned on the radio. She tried a few stations, found something not too challenging, and began. Or rather she attempted to begin, but her feet felt like they were strapped into iron pots. She changed the music and tried to loosen her upper body. But it was worse, if that was possible: her arms and chest behaved as if they were encased in a thick layer of drying mud. Suddenly, she

was very frightened. Nothing like this had happened before—dancing was second nature to her. She hurried to the radio and swung the dial back and forth until she found something with more expression. Nervously, she forced herself out onto the floor again. She spread out her arms and began to spin like a top. It was something she'd mastered from an early age and, with her eyes fixed on one of her thumbnails, she could keep going for what seemed like an eternity. But on this day, after only four or five rotations, she came crashing to her knees.

Panic soon transformed itself into dark despair. Head in hands, Ana remained where she had collapsed and allowed sobs to overwhelm her. How could she crumble so pathetically? Where was her fight? Her courage?

The music had stopped, the announcer hadn't yet returned to his microphone, and the only sound other than Ana's tears was that of the pigeons exchanging positions on the beams high above. Surely the heavens couldn't have brought me this far, only to send me back to the camp, she thought. Did Felix know this was going to happen to her? Is that why he'd sent her packing?

She could hear feet padding quietly across the mosaic floor. Strong arms lifted her up. Sirocco placed her in a chair and was saying, with his customary kindness, "Tell me."

Humiliated by the thought that he had seen her fall, Ana didn't respond. Finally, with her mouth muffled by her hands, she replied, "I . . . I don't know how."

Sirocco did not ask for explanations. Instead he waited patiently till her tears had subsided, and then, while she dried her eyes, he cradled his drum and

rippled his fingers across its surface, making the sound of distant hooves running across a plain. Ana looked up just enough to watch as he began to play. His music couldn't cushion her fall from grace, but it did distract her from the hopelessness.

Inside her pain, Ana could still appreciate the degree of Sirocco's generosity. He was a good person. More than that, he was caring; and he seemed to have an instinct for being close when she needed help. She watched his dark hands flying over the taut drum skin and was deeply grateful.

The following morning Ana came again to the restaurant, not to dance but to play her new flute. It had been given to her by Mr. Hamattan when she was leaving the *Mistral* after their voyage. He'd wrapped it in a cloth and placed it in a box and she hadn't discovered what it was until it she was unpacking her bag. Ana had stared blankly at the instrument. "I'll have to give it back," she had said to Halle, who was standing next to her, tapping hard on the glass cover of the barometer that hung on the living-room wall. "This instrument is far too valuable to keep." Ana was starting to add together all the things Mr. Hamattan had done for her.

Halle had turned her back on the barometer. "The flute is too valuable to return, you mean." Ana looked at her in surprise. "Rejecting such a gift would be an insult. It was freely given and doesn't oblige you in any way," she'd added.

Now, Ana came into the sun-filled restaurant with the flute in her hands. Sirocco was waiting. He smiled and gestured invitingly to the chair opposite him. When she was seated, he began to play. She followed his lead, letting him dictate the pace and direction. She had to concentrate hard to stay with him

because his rhythms were both foreign and complex. Whenever she felt she was starting to see where he was going, he changed direction. It was fascinating. He never let her get comfortable with the obvious. Musically, she had never worked so hard.

After an hour, he began to leave spaces, spaces she tentatively filled. After nearly two hours of speaking only in music, Sirocco paused and indicated to Ana that she should stand.

Ana waited for him to start again. But he didn't move. When it was clear that he wished her to lead, she again lifted the flute to her lips. Because she was self-conscious, she stayed with passages she already knew. After a few moments, Sirocco held his hands up and Ana stopped playing.

He lowered his head as if in prayer, and then he began a tattoo, tapping out something she'd never heard before, something even harder to follow than the paths she'd already been led down. Far back, she recognized the sounds as one might know a familiar stranger. Ana blew tentatively across the flute's mouthpiece. Again she followed him as best she could. Now that she was standing she found herself swaying very slightly with the music. It was an involuntary movement and it brought her a sense of small relief.

Then another sound started. It was high pitched, not a singing or a humming, yet it came from Sirocco's throat, a near-animal vocal thread that wound itself into Ana's body, pulling at her, sending her hips one way and her shoulders another.

Ana was in a quandary. It was her afternoon to give Mr. Hamattan his music lesson, but she couldn't teach the unteachable. It was obvious that he was never going to be able to play. What she needed was a way to tell him this without hurting his feelings. She was surprised to find how much his friendship meant to her—she didn't want it to come to an end.

She was almost at the *Mistral*'s berth and still trying to decide how to broach the matter when she almost bumped into him. Mr. Hamattan was standing at the top of the walkway, wearing a coat and scarf. On seeing him dressed to go out, Ana at first thought that she must have the wrong day.

"What a wonderful way to celebrate a new season!" he called, waving in the general direction of the cloudless sky. "I hope you don't mind, but I have a change of plans. Would you care to come for a walk with me? Do say yes! I have something I'd like to show you. And while we're at it, we could talk about my appalling failure as a music student."

He put his right hand in his coat pocket and offered her the crook of his arm. "Here. I shall be the coxswain," he said in debonair manner.

Relieved by the reference to his hopelessness as a musician and cheered by his enthusiasm for the day, Ana linked her arm with his and allowed herself to be steered off in the direction of the park.

"I wanted to thank you for my flute," she said. "You really shouldn't have given me something so valuable."

"Nonsense, my dear," replied Mr. Hamattan. "It was meant for your lips, not mine. I was obviously never going to come to grips with it, whereas in your

hands it springs to life. That was my way of saying thank you for helping me try to master something that is utterly beyond me."

"Maybe you could try another instrument, "she offered. "Something that doesn't require such difficult breath control."

"It's strange you should mention it. That's one of the reasons for this stroll," he said with a hint of mischief.

"Where exactly *are* we going?" inquired Ana, who didn't really care, because she was so relieved that Mr. Hamattan had saved her from an uncomfortable task.

"Have you heard of Alvarez Tachardo?"

"The poet?" she responded tentatively.

"The very man," replied Mr. Hamattan. "He lived here in Serona for many years. He was a keen gardener and built an arboretum on the grounds of his estate." By then they had passed the park and were heading toward a wealthier part of the city. "As you may be aware, Alvarez died over thirty years ago, but the family has honored his wishes by opening their garden to the public three days a week. As part of the ongoing renovations, I was asked to bring my expertise to bear on an aquatic problem."

They had been walking beside a tall stone wall and when they came to a heavy wooden side gate, Mr. Hamattan leaned over and flipped the latch. He led Ana down a gravel path between rows of fig trees and clusters of black bamboo. They emerged onto a close-cut lawn. Standing in its center was a large building made of glass. It was an octagonal, three-tiered structure,

easily twice the size of Halle's house. The wooden framing that held it together had been painted green to blend in with the wild profusion of tropical plants that filled its interior and threatened to burst through the restraining window panes.

"Wonderful," breathed Ana. "I didn't know they built palaces for plants. Can we go inside?"

"Of course," replied Mr. Hamattan. He unlocked an ornately carved padlock and pulled open a door of glass. Inside was a tropical jungle, lush and steaming. The heat enveloped Ana and immediately started to cook her. Mr. Hamattan peeled off his coat and Ana quickly followed suit by removing her sweater. She looked up at the massive leaves of the cocoa and banana trees and then down at the thick tangle of vegetation that crept along the floor.

"I love this," said Ana gleefully. "I always wanted to visit the equator!" She wiped away the beads of sweat gathering on her forehead.

"All of the beauty with none of the disadvantages of poisonous snakes," confirmed Mr. Hamattan, plunging into a wall of woven greenery. "Come along," he demanded, penetrating the jungle with a knowing confidence.

For a moment, Ana was reminded of her journey into the underworld with Boreos. Except Mr. Hamattan was far less dangerous than Boreos, of that she was certain. She followed obediently.

Unlike her cave experience, this journey lasted just half a dozen paces before they were confronted by another door. Around the frame and across the wall that held it were ranks of shiny turquoise and white tiles. Ana's gaze followed

their intricate pattern upward through a veil of leaves to the squat curve of a bronze dome.

"How strange," Ana found herself saying aloud.

"Remarkable, isn't it, my dear? Who would build a building within a building?" Mr. Hamattan was enjoying his role as tour guide. "Do you know what it is?"

"I haven't any idea," replied Ana, touching the cracked surface of the old tiles.

"It's an early Mauresque bathhouse. It was constructed over four hundred years ago, when the Maure Empire was in its prime. The Tachardos built the greenhouse around the existing structure in the middle of the last century, having been convinced by their architect that they could nurture the exotic plants with heat from the bathhouse's boiler."

Ana could hear the low throb of something mechanical coming from behind and below the walls. "Is that the boiler I can feel under my feet?"

"Exactly right," replied Mr. Hamattan. "It used to be run by a wood furnace, but now it's powered by electricity." Lightly, he steered her toward a small staircase that led down to the boiler room.

As they ducked their heads to enter, Mr. Hamattan began explaining his involvement with the place. "The family asked me to supervise the replacement of the original hydroaquatics that operate the water supply. I talked them out of it and suggested that they let my people replace only the joints that were leaking." He beamed proudly at an unassuming metal pipe and then turned to Ana. "But now, let me show you my little secret." Obviously pleased with himself, he took her into an adjacent room where the main pump was housed and

turned the power to full. Water began to sluice, making grumbling noises as it passed through the pipes. "I did some experimenting with these," he said, pointing to what looked like five metal watermelons placed at regular intervals along the largest section of piping.

By then the sound in the small room had grown considerably—to a chaotic mess of burbling and clanking. Mr. Hamattan started rushing up and down, twisting dials, tapping sections of the pipe and fiddling with valves. He looked very peculiar indeed, and Ana was on the verge of doubting his sanity when something utterly unexpected happened. The cacophony that was jarring their heads started to rearrange itself and the disparate sounds magically began to align. Ana's face lit up as she realized what Mr. Hamattan was doing. He had actually found a way to orchestrate the waterpipes. They were arranging themselves into the same haunting music that his water boxes had played back on board the *Mistral*.

"That's incredible," she murmured.

He smiled at her awestruck face. "Yes. It's truly astounding what water can do. Unfortunately, as soon as I stop adjusting the compressors, it starts to deharmonize. I'd like to be able to control it so that it's stable. But I fear I may not have the opportunity."

"Mr. Hamattan, you are a genius!"

"Thank you, Ana. But I am merely indulging myself," he replied with what seemed genuine guilt.

When the music had subsided back to a series of gurglings, they wandered back to the room with the main bath, where Ana admired the pale blue and

rose frescoed walls, the hanging baskets, and the exquisite circular bath with its dark ultramarine tiles. The pool must have been at least ten arm spans in diameter. There was something immensely inviting about the still water, and Ana became acutely aware of her clammy skin.

She was about to remark on the perfect calmness of the scene when Mr. Hamattan started to take his clothes off. He was chatting away over his shoulder, still talking about pipes and their tones, as he placed his garments on a wooden bench next to a pile of folded towels. When he was naked, he descended the tiled steps into the water.

Ana was lost for words—or even thoughts. But Mr. Hamattan seemed to be totally devoid of embarrassment. "Are you not coming in? The water's warm but it feels refreshingly cool compared to the air temperature."

She stared at him in astonishment. What was he doing? Was he trying to lure her into his pool to seduce her? Perhaps he was an exhibitionist, but why then would he seem so nonchalant? Ana's mind was racing. She thought of the foot massage Mr. Hamattan had given her—suddenly she wasn't sure if his actions had been as innocent as they had seemed. She didn't want to misinterpret the implications of his offer—one way or the other. "Thanks," she stammered. "I'll just stay here and stand guard."

"You don't have to be concerned. This is not a public day," he said reassuringly.

Had he truly misunderstood her, or was he playing the serpent? Maybe she should leave, but she had to admit the water did look tempting. She was boiling. Could she simply undress and climb in? "Thank you, no," she said.

"Maybe next time." She knew her answer sounded feeble, but she didn't know what else to say.

And she didn't know where to look. Despite herself, her eyes were drawn to the spectacle of Mr. Hamattan, who was obviously enjoying his bath. He picked up a long-handled brush and scrubbed his back vigorously. He seemed remarkably youthful, his back strong and powerful, and Ana found herself wondering again how old he was. There was a shaft of light coming through the dome window that reflected off his radiant skin, and for a moment he looked almost godlike. Ana couldn't stop staring at him. She realized she'd never fully looked at a naked man before. She'd seen, from a distance, the occasional unclothed body washing itself at the camp's pump, but she'd never let herself look properly. Even with Boreos she hadn't felt assured enough to step back and take him in. Watching Mr. Hamattan flexing, stretching, and bending at the mundane task of cleansing himself, Ana felt a distinct sensation of pleasure. It wasn't exactly a sexual feeling, though that too hovered in the background; it was more of an acknowledgment, an appreciation. If only she possessed his calm, she wouldn't be scared of failing. She wanted the patience that he seemed to carry within. If, when she was dancing, she could maintain that kind of stillness, maybe it would counterbalance her tendency to overextend. Ana sat a little straighter, no longer furtive in her examination. If she had been able to make time stand still she would have waded into the water and washed him herself, let her hands soap his body, examining the soft, the hard, the rough and smooth, all of the shapes and all of the angles. Possibly she would have been tempted further, but that wasn't the point of the matter.

What satisfied Ana was that she felt grown-up enough to take delight in something that was so pleasing to her eye.

But she didn't plunge into the water. Mr. Hamattan's interpretation of such an act was not something she was willing to deal with. The only thing she could do was what she was doing already—observe him.

He stayed in the pool for about five minutes, and then he got out and rubbed himself dry with one of the large white towels. Once dressed, he looked at her rather gravely, "In my country, men and women bathe together. I confess that in my state of musical euphoria, I was not thinking clearly. It has only just dawned on me that not every culture accepts public nakedness between the sexes. I hope I didn't offend you."

"No. No, not at all," Ana said. Then, more bravely, "You have a good strong body."

"You are very kind. I'm sure if you'd joined me in the bath I would be complimenting you in return."

The thought of Mr. Hamattan looking at her as explicitly as she had looked at him made Ana flush. Why was it, she asked herself, that it seemed easier to make love with a man than have another study her nakedness? It didn't make sense, and yet it was undoubtedly true.

16

On my bed when I got home that evening was a note from Zephyr:

> A. If it's not too late when you get back, come to the wharf, gate
> 320. There's something I'd like to show you. Z

I had been on my feet all day and, until that point, all I had wanted was to sit down and have something to eat, but I hadn't seen Zephyr for a while. We rarely seemed to be in the house at the same time lately. I had to admit I missed the tingle of excitement I felt around him. After everything that had happened in the last week, I wanted his company. Or, more truthfully, I wanted to continue our flirtation. So I hauled myself up to my bedroom, changed my clothes, splashed water on my face, and headed off to find gate 320.

The wharf had been built during the glory days of the city's sea trade and, although it was still moderately well used, the area had become scruffy and run down. Not that I found it depressing; in fact, it had maintained a tenacious

architectural grandeur, displaying in its stones a resilience that had withstood hard work, climate change, and the pounding of the sea.

A ship approaching from the ocean would have first glimpsed the two gigantic ramps that zigzagged their way up to street level. These ramps, which looked like great wedges of cheese, allowed cargo to be hauled from the landing docks up their inclines to the great stone wharf above. Along the city side of the wharf ran hundreds of warehouses, each set back behind rows and rows of linked arcades.

I felt the bite of autumn in the night air as I walked beside the seemingly infinite strand of arches, counting off the numbers. I could see that many of these storehouses had been unused for years. A few—and my destination turned out to be one of them—had been made into workshops and small businesses.

I knocked hard on the heavy, weather-beaten door of number 320. After a pause, a smaller door set within the larger one opened with an eerie creak. Zephyr's head popped out. "Hello," he said, looking pleased to see me. "You found it then."

"I suppose I must have," I replied sardonically and regretted it at once. I had resolved to stop using that ironic tone with him. Why was I still doing it? Maybe, underneath, I was concerned that I'd sound *too* interested if I softened my response. But was that so wrong? After all, I *was* interested in him.

Zephyr helped me step over the threshold and into the workshop. The room was lit by three oil lamps that were suspended by ropes hanging from a broad rafter. I wondered why there was no electricity. Later Zephyr explained that it would have been far too expensive to introduce such modern refinements to

this sparsely populated area of the city. Most of the businesses were content to keep things as they had been for the previous two hundred years. If I had worked here, I would probably have felt the same. I'd grown up without electricity and, while I appreciated its benefits, my stay in Serona had left me nostalgic for the soft lamp glow of my childhood.

When my eyes had adjusted to the light I made out the rough-hewn stone walls and the high, curved ceiling. I could also see, in the middle of the work-shop floor, supported by trestles, the freshly cut wooden skeleton of a plane.

"This," beamed Zephyr, "is my new pride and joy. And *this*," he gestured grandiosely in the direction of a wiry man with thick round glasses, "is Philippe: master carpenter and comrade in the art of aeronautics."

Philippe grinned at me as he brushed his overalls free of sawdust. Once he'd made himself fit for company, he came over and shook my hand.

"Pleased to meet you, Philippe," I said, giving him a wide smile.

"Zephyr, you told me you had a beautiful friend coming to visit our flying machine, but the extent to which you understated the truth is unforgivable." Philippe's voice was not what I expected. It was deep, with a melodic lilt. It made his flattery both charming and slightly disconcerting, particularly given that his bottle lenses made his eyes look as if they were behind twin tunnels of fog.

"Thank you," I said, shyly. I still did not know how to receive such direct compliments. I turned to Zephyr, "How long have you been working on this? You didn't say that you were building a new plane."

Zephyr gestured toward a blueprint lying on a nearby bench. "I drew the plans up shortly after I arrived in Serona, but it took me awhile to find

Philippe. He's done an amazing job in a short space of time. He's just finished building the frame and we'll soon be stretching the skin."

"Stretching the skin?" I queried.

"Attaching the cloth to the frame. Once it's taut we coat it in that acetone dope," he said as he pointed to a bucket, "which stiffens the canvas and protects it from the elements."

A cloying scent of pear drops wafted up from the bucket.

"I recognize that smell," I said. "My grandmother used to make her hats with that. She told me that the old milliners would go mad sniffing the stuff."

"What do you think of her?" Zephyr asked, brimming with enthusiasm.

"My grandmother?"

"No, no. My plane."

"It's extremely . . . interesting, to see an aircraft so . . . undressed. I find it hard to imagine what it's going to look like when it's finished. Is it very different from the one you left up in the tree?"

"Yes, completely. This is a design I've been wanting to try out for ages. The last one was a biplane. As you can see, this has only one set of wings, and the propeller will be mounted on the nose. It should be way more stable and a lot faster."

Zephyr launched into a highly detailed description of the plane's finer points and I followed as best I could. After a few moments I had to admit I was getting lost. But I could see how happy it made him to talk about horizontal stabilizers and I liked his animation. I watched his slender face in the lamplight, and when he paused for breath I grabbed the opportunity to backtrack. "Forgive my

ignorance, but how does it actually work?" I was running my hands along the wing tips. "I mean, how does a wing like this make a plane fly?"

He stopped to think about my question, and I could see that he truly wanted to help me understand. "All wings," he began, quickly gathering pace, "are subject to the same aerodynamic principles. Lift is achieved when the air that passes over the top of the longer, curved surface of the wing is stretched thinner than the air passing under the shorter, bottom surface. With more air under the wing, pressure builds and forces the plane up. The larger the wing area and the faster the air speed, the more powerful the lifting force. Lift also comes from the angle of attack—that means the angle of the wings relative to the airflow. The steeper the angle, the stronger the lift. However, if the angle gets too steep and not enough air passes over the top of the wing, lift disappears and the plane will stall, or lose its forward and upward motion. Does that make sense?"

Surprisingly enough, it did. I pictured the swifts I had often watched over the campsite, and for the first time I understood why a bird's wings are shaped the way they are.

Philippe, who probably knew all he needed to about aerodynamics, had retreated to the tail of the skeleton and was rubbing away with a sheet of sandpaper. After a further volley of information on the differences between pitch, yaw, and roll, Zephyr came down from the clouds. He looked at me apologetically. "I guess I'm getting carried away. Shall we go outside and get some fresh air?"

"I'd like that," I said, relieved that I was at last going to get him to myself.

We sat on the dock with our feet dangling high over the water. The moon was a crescent and the night was clear. We looked out at the lights of the late-returning fishing boats as they shimmered on the ocean.

"I can't wait to fly over this place and see what it looks like from above."

I laughed. "Do you see everything in terms of flying?"

"Not everything," he replied slowly. "Just most things!"

It seemed foolish, but I was starting to get jealous of his plane. I had imagined a dalliance in the moonlight, and now I was having to wrestle for Zephyr's attention with a half-built flying machine. I resorted to a cheap ploy. "Suppose *I* were a plane—what would I be like?"

He looked at me keenly. "Mmm. That's a tricky one. I'd say, quick to rise, elegant in flight, but . . . extremely difficult to land."

"Difficult to land," I repeated. "What do you mean by that?" It suddenly dawned on me that he'd been playing me along, pretending to be distracted.

"But not impossible," Zephyr murmured, brushing my cheek lightly and slipping a loose strand of hair back over my ear.

I turned my head to look at him, whispering, "I was wondering if you'd ever get around to this."

"I didn't want to hurry you," he replied, keeping his eyes on mine.

Was I being hurried? No. But I did find myself reflecting on how little I knew about him. We were silent for a while and then I asked, "Zephyr, why did you leave your homeland?" I was taking a chance asking him such a revealing question at that moment, but I didn't want to become involved with another Boreos—someone who was evasive and controlling.

I felt him stiffen slightly. I wasn't sure if he was going to answer. Then he said, "The cruelty and indifference I saw all around left me angry and then numb. The sky was the only place I could escape. But whenever I came back to earth, I became disillusioned again. I decided I'd rather be anywhere than where I was. So I filled my plane with as much fuel as I could get in the tank, took off, and here I am."

His answer was full of emotion, yet it still told me very little of who he was. Not that I thought him glib. In fact, I decided that he was probably just unprepared to articulate the painful experiences that still haunted him.

"Don't you miss your friends and family?" I tried a different tack.

"My friends are long gone, and as for family," he smiled, "are we ever far from our siblings?"

"You have brothers and sisters?"

"I have three brothers and one sister. I am the youngest."

At last, something concrete. I was going to ask more but he interjected, "What about you? Do you miss your family?"

I didn't need to think. "I miss my grandfather. And in a way I miss my parents. But mostly I have to say I'm enjoying my liberation."

"Liberation," he repeated. "I like that. It feels good to be liberated from the struggle."

Again we slipped into silence. Most of the boats had landed and the lights on the water were fewer and farther between. "What will you do when the plane is finished?"

"Fly it?"

I nudged him with my shoulder. "I know that! I meant, are you going to explore the countryside around Serona or do you intend to fly home?"

Zephyr looked at the black water. "I suppose I will eventually return, even if it means keeping going until I arrive the long way around. But for the time being I'll need to do some test flights." He brightened. "And then, when I know she's safe, I'll take you up in her. I'll even show you how to fly if you like."

"You promise?" I was unbelievably excited at the idea of really flying.

"I promise. But now I've got to get going," he said resignedly.

"You are coming back home with me, aren't you?" I said, not liking the fact that his tone suggested otherwise.

He glanced away from me. "I wish I could. But I have to work through the night with Philippe. He's got a hull coming in in a couple of days and the plane has to be completed and out of the workshop by then. We've still got the engine to mount and the prop to carve." He shook his head as if to clear his thoughts. "Of course, I'll walk you home."

"That wasn't quite what I had in mind." The strength of my disappointment surprised me a little.

"If I don't finish it, I may not get another chance," he said seriously.

I stood and pulled him to his feet. "I would never have guessed you to be such a sensible man," I said, trying hard not to show my frustration.

Wincing, he said, "She strikes me with a cruel blow! All right, what if I promise not to be sensible all the time?"

He was so impossible to stay annoyed with! I took his hand.

We began the walk back along the seafront and I noticed that the scratch marks from his forest climb had long since healed and his hands felt smooth. About halfway along the wharf I stopped and faced him. "Kiss me."

"Here?" he asked with feigned surprise.

I looked around. "No," I replied. "In here." And I pulled him into the nearest deserted archway. He needed no second invitation; his mouth came down on mine as he wrapped his arms tight about me. The alcove was dry and smelled of tar and salt. I didn't want to play any more games—I wanted him there and then. He had me pressed against the pile of sandbags that were stacked against the doorframe. I loved the feeling of his weight against me. I had my hand under his shirt and was running my fingers down the flesh of his back. His lips were on my neck, my shoulders, and then my breasts. Then suddenly he stopped. "We are being watched," he whispered, his voice hoarse.

"What?" I said, barely able to get my breath.

"There are voyeurs afoot."

"Who? Where?" I twisted my head first one way then the other. He pointed downward at the seven or eight rats who had clustered around our feet. I like most creatures, but rats have always made my skin crawl. It took all my willpower to stay still and not start climbing up the wall. I clutched at his hand. "Get me out of here," I rasped.

"Hold on," he said, reaching into his pocket and pulling out a small box of matches. He quickly struck a stick and let it fall. As the lucifer hit the ground, the rats scuttled backwards. Zephyr grabbed my sleeve and we made our escape.

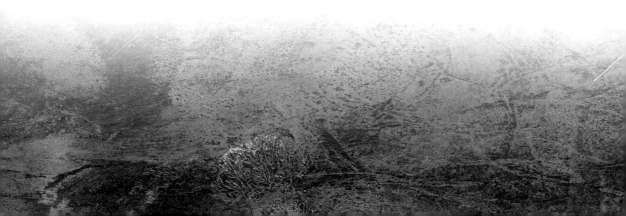

"Not the most romantic place to start a relationship," Zephyr laughed.

I shivered and straightened my clothes. "That was not funny! Okay, it was funny," I giggled. "Their timing was terrible." Standing back out on the moonlit wharf we could hear a group of men below dragging some kind of heavy pallet along the cobbles.

He kissed me again.

"Are you sure I can't lure you to my bed?" I asked.

He groaned. "I don't want to make love with you and then rush off." His arms closed tighter around my body.

"Come on," I said, untangling myself and taking his arm. "I shouldn't tease you. Or me, for that matter."

At Halle's gate he kissed me once more—a long, strong kiss that left me quite shaky. "I'll see you in the morning," he said, waving as he headed off to spend the night with my competition. I smiled to myself. I didn't really mind. Zephyr had declared himself and that was a good start.

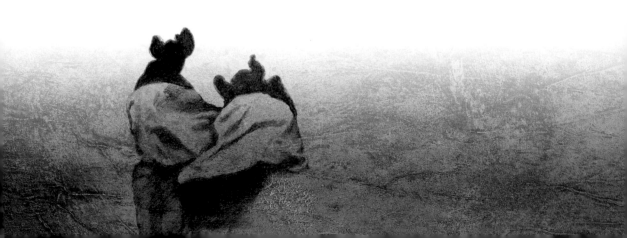

17

As Ana fell asleep, her mind filled with Zephyr, the moonlit wharf, the ocean scent, and a wooden bird that sailed over the city of Serona.

She awoke with a start in the early hours of the morning, filled with a longing to speak with her grandfather. She slipped out of bed and put on the thick woolen socks she used as slippers. Not wanting to turn on the bright light, Ana lit one of the beeswax candle stubs that Halle had brought back from the restaurant. She pulled a blanket over her shoulders and sat down at the small writing desk in the corner of the room. With impatience, she fumbled around in the drawer until she located paper and a pen. Flipping back the lid of the inkpot, she tentatively dipped the nib into the tiny pool of ink.

My dearest Grandpa,

I know I don't have to explain to you why I ran away. You of all people must have understood that it was the only thing I could do to be free and to stop my father from tying our people to the valley.

You haven't been worrying about me, have you? If you have, I promise that I am well and safe.

Have you heard from Felix? Did he tell you that I'd been to Anangion to see him and that he had rejected me as a pupil? I was so sure he'd become my dance teacher. You always said that he believed the duende would run through me and I would be the one to guide the Capolan like the dancers of old. When he told me that I had to teach myself I was so distraught that I even forgot to ask him about the letter you sent with the news of home. I hope you are well and full of heart. Has Papa disowned me? How's Pax?

I've not given up trying to dance, but it's so hard to do it alone, and since I came back to Serona after seeing Felix I seem to have lost my confidence or balance or something. I wish you were here to guide me, like you used to. If I close my eyes I can still see you sitting on your tree stump banging out a rhythm with your walking stick. I'd spin and spin and follow that feeling in my toes that you called my magnets. And I remember when Grandma was still alive, the way she would clap her hands to keep me going. I never even realized how much I depended on your lessons and your belief in me. When I left the camp I thought Felix would take your place—as much as anyone could, anyway. But my fate appears to be otherwise.

While my dancing seems stuck, you'll be pleased to hear that my flute playing is thriving. In that, at least, I have found someone to direct me. He's a strange and quiet man, but his knowledge of

music is remarkable. And I'm being shown all manner of rhythmic possibilities I never even knew existed.

I miss you all terribly, especially you, Grandpa. But I'm not sorry I came to Serona. You were right—it's a very special place—though I haven't yet seen any of those eight-legged giants you used to describe in your bedtime stories!

I'm staying here at my friend Halle's house and you can write to me at her address. Please do.

I love you very much.

Ana

She carefully addressed the envelope, disguising her handwriting to make certain that her return address didn't become common knowledge. Ana blotted the ink dry and crawled back into bed. Within seconds she slipped into a deep sleep. She awoke refreshed and excited at the prospect of the day. Her anxiety about dancing was temporarily pushed aside by the promise of Zephyr and the knowledge that she had begun a conversation with her grandfather.

She chatted cheerfully to Halle over breakfast and then, grabbing her letter, set out for the market. Passing the brass porpoise-shaped postbox on the corner of the street, she slid the envelope into the creature's mouth and watched it disappear. Would her grandfather write back immediately? She crossed her fingers and blew on them for blessing.

The morning was breezy and Ana had to wrap her scarf a couple of times around her neck to make certain that it wasn't whisked away from her. The

awnings over the tables were billowing and those stall owners with paper goods were having to weight their inventory down.

At her favorite fruit and vegetable stall, Ana found herself standing next to a familiar figure. "Buying anything interesting?" she inquired.

Sirocco turned. Seeing Ana, he smiled and opened wide his cloth bag. She peered down to see three oranges and a bunch of grapes. "And you? What are you searching for?" he asked.

"I told Halle I'd cook tonight." For a brief moment, Ana thought of inviting Sirocco, but she rejected the idea. They already had two guests. Junto was coming, and since Zephyr was busy with his plane Halle had suggested that Ana invite Mr. Hamattan. Now the wind was whipping at Ana's skirt, so she gripped the fluttering material and held it to her thigh. "Do you have anything else left to buy?" she asked.

"Just some bread and maybe some olives," replied Sirocco. "Would you like me to help you carry your groceries?" he offered.

"That would be wonderful. I was wondering how I was going to manage everything." Then, as an afterthought Ana added, "You really have helped me so much already." As the words left her mouth she fleetingly thought, Why has he been so helpful?

Ana bought enough supplies for the whole week, and before long they were both laden like pack donkeys. "Are you sure you want to do this?" Ana asked, wondering if she should ask Sirocco directly why he had taken it upon himself to look after her. Would he consider that impolite?

On the corner of a street, they passed a thin, hunched man who was playing a popular but tired tune on his cheap fiddle. In front of him was a worn cardboard box containing a few coins. Sirocco stopped and whispered into the beggar's ear. The man immediately stood very straight and started to play something quite different, a sonorous and haunting melody that caught on the crosscurrent and drifted back down the street to the marketplace.

Ana was astonished by the transformation. She started to hunt through her purse for some change, but Sirocco shook his head. "Give him some food."

"What do you think he'd like?" asked Ana, for some reason assuming that Sirocco would know.

"Give him those ripe pears," Sirocco nodded toward her bag. "He needs fruit."

Ana took the pears from the top of the bag and placed them carefully in the box. The man grinned toothlessly.

As they walked away Ana asked, "What did you say to him?"

"I told him that all of the tribes of one were relying on him to speak for them on this day."

Ana frowned, "The tribes of one?"

"The people of the streets, the wanderers, those who have no homes to return to at night. There are many thousands of them in this city alone."

Ana thought to herself that if Halle hadn't helped her she might well have been on the streets too. Sirocco continued, more animated than she'd ever seen him before. "There are some, of course, who are lost inside broken minds, but

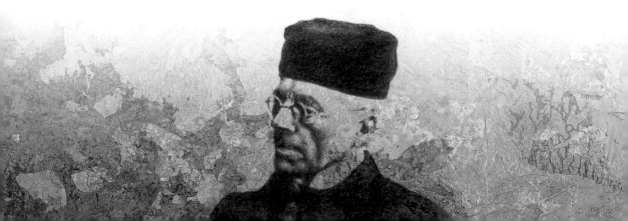

most simply choose not to accept the demands of a regimented life. They possess little. They eat when they can, sleep where there is opportunity."

Ana remembered the lone travelers who would sometimes turn up at the Capolan campsite. "My grandfather always insisted that we give them food and a place by the fire," she said thoughtfully. "But I must confess that here in the city I haven't taken much notice of these people. I feel bad now. A tribe should be honored, no matter how small it is." She could still hear the fiddler's tune in the distance. "You have an affinity with these people don't you?"

"I feel strongly about them. And I believe that a nation that ignores its individuals does so at its peril. It seems to me that a person without possessions should be treated with the same dignity as one who owns much. But there is no one to speak for them; by their nature, they cannot unite in a single voice."

Ana was starting to see yet another aspect of the intelligent man next to her. "What is the answer to their problem, then?"

"The problem is ours, not theirs. *They* have nothing to lose." He cast his arms around. "It is up to all of us to share what we have."

"And if we do not?" she asked.

"Who knows? Maybe a cloud of locusts will gather and devour everything in sight. Or maybe the winds will simply sweep it all away," he said cheerfully.

Ana turned to look at him, but she was unable to tell if he was serious or joking. Falling silent, she pondered the things he'd been saying. Then she asked, "What tribe are you from, Sirocco?"

His answer was carefully measured. "A tribe not unlike the Capolan. A tribe in need of a reliable compass."

They had arrived at Ana's gate, and she collected her purchases from him. "Thank you for the help and for talking with me, Sirocco." With a touch of formality she said, "I hope we can continue our conversation sometime. I'll see you tomorrow morning at the restaurant."

That evening, Junto was the first to arrive, bringing with him flowers for Halle and a good bottle of wine for the table. Halle commended both of his choices, took his coat, and kissed him. Ana was standing at the end of the hall, rosy cheeked from checking the progress of the food in the oven. She thought Junto looked nervous, but maybe that was to be expected: he was probably anxious at the idea of having dinner with his newly acquired lover, an employee, and a client.

"Ana, could you take Junto's bottle of wine?" Halle called down the corridor.

Junto's eyes had been on Halle and he hadn't seen Ana until she was mentioned by name. "Ah, Ana! Good evening," he nodded stiffly.

"Hello, Junto," she replied, squashing an impish temptation to hug him, just to see how he would respond.

Mr. Hamattan was on time. Which meant he came half an hour later than Junto. Halle had had the sense to stagger her guests' arrivals in order to give Junto a chance to adapt to his new surroundings. Working in the kitchen meant that Ana missed the early conversation, but from the occasional laughter she could tell that the other three were doing fine without her.

When Halle helped carry the meal to the dining room, both men offered to assist, but their offers were scorned. "Leave it to the professionals," Halle taunted.

Ana couldn't resist teasing her boss, "If I drop a plate, I'm sure you'll catch it, Junto."

The discourse was light and cheerful through the soup and main course of peppered turkey, ginger orange fennel, and couscous. Halle, Junto, and Ana chatted about life behind the scenes at the restaurant. Mr. Hamattan listened in fascination as Junto described Ranier, an ex-chef who would grow enraged by any customer returning one of his meals. "On one unforgettable occasion," Junto related, "a patron was stupid enough to send back the same meal *twice*. Marko went out and apologized to the man profusely. 'Please let me make amends,' he begged. Back in the kitchen, he poured half a bottle of laxative into the masala before returning it to the table. The impertinent fool of a customer was doubled over in agony even before he'd left the premises. Of course, I had to fire Marko, but he didn't object. As far as he was concerned, his honor had been restored."

Apparently reminded of unpleasant customers, Junto asked Ana, "Have you had any more problems with that pair of buffoons we threw out of the restaurant a while back?"

"No," Ana smiled. "Sirocco dealt with them, and I doubt that they'll bother me again."

Junto raised an eyebrow. "From what I heard, you pretty much disposed of them yourself." Ana looked at Halle, who shrugged as if to say, Nothing to do with me. "I have never understood why people are abusive toward the Capolan," continued Junto, "but then again, I've never understood why anyone considered bloodline relevant to individual worth."

Maybe it was because his guard had come down that Ana noticed the thickening of his accent.

"If it's the upper classes you're referring to, I think they have always seen the world in terms of breeding—probably because of their fondness for their racehorses," quipped Halle. "But I believe the men who attacked Ana see the Capolan or any other minority as a way for them to confirm that they themselves are not at the bottom of the ladder."

"Could it be that the Capolan, and any others who fail to fit in the social hierarchy, are a threat to order?" proposed Mr. Hamattan in his refined tone. "Their perceived crime is one of unaccountability. Thus, they have been ostracized and punished for their implicit criticism of the way the majority lives."

"So you believe my people have been persecuted not for our race but because we do not own land?" Ana asked.

Mr. Hamattan considered. "Perhaps you are simply envied for your freedom of movement by those who are trapped by predictability, regardless of their class or status."

Ana was thinking about her conversation with Sirocco earlier in the day. "What then of the tinkers and the street people? Why are they ignored rather than openly picked upon?"

Junto, who had been listening intently, jumped in, "Because they are not enviable."

Ana reflected. If the old ways of the Capolan were secretly looked upon as something to envy, then did that not confirm her belief that it was a mistake for the tribe to stay in the valley?

"Mr. Hamattan," Halle asked, "in your country, is there a strong class system?"

"Strong? Yes, I suppose it is strong in the sense that those in authority are responsible for those below them."

There wasn't much doubt in Ana's mind that Mr. Hamattan was part of the *above* rather than the *below*.

"Then you agree that those in high places should watch out for those beneath them?" continued Halle.

"*Beneath them* is a loaded expression. However, yes, I do consider that the responsibility lies in the hands of the privileged. That is not to say that it is invariably possible to direct all one's energies to the welfare of others."

"Surely then, you agree that there is a difference between fulfilling lofty obligations and indulging in one's preoccupation?" Halle responded, fixing Mr. Hamattan with a penetrating stare.

Ana didn't understand where the sudden sharpness of tone had come from. And it seemed peculiar that Halle, who had such natural charm, would speak to a guest, never mind a customer, in such a way.

"Is responsibility not a matter of each individual's view of himself?" asked Junto, oblivious to the tension between his lover and her other guest.

"True," replied Halle, turning to Ana, "but if you are treated as inferior, is it not hard to ignore the injustice?"

"For me, not really," replied Ana. "I know I am no lesser person, whatever anyone might say. But many of my people have become defensive and in that

defensiveness they have learned to accept their lowly role." Again Ana thought of Sirocco's remarks "By giving up their roaming and trying to mimic the landowners, my people are losing their dignity and their identity."

"What then is the key for the Capolan? To pull up camp and become vagabonds once more?" asked Mr. Hamattan.

"To an extent, yes. But they also need to regain their belief."

"Belief in what? Surely not in superior beings sitting up there in the heavens?" Junto sounded as if his intelligence had been affronted.

"You do not believe in the gods?" asked Mr. Hamattan, leaning back in his seat. Ana noticed Halle give him a quizzical look.

"It seems to me that the gods have always looked after their own well-being rather than ours," replied Junto. "Even if I did believe in their existence, what do they have in common with us?"

Halle was having trouble keeping a smile from her face.

Junto was getting up a head of steam, "The gods were supposed to oversee right and wrong, yet they appear to know nothing of our lives. If they exist then they are guilty of the worst of all sins. They are willfully ignorant."

The room was quiet. Halle looked tentatively at Mr. Hamattan, waiting for his response.

"Junto," declared Mr. Hamattan, "I like you!" He clapped the little man on the back. "You are a person of conviction. I raise my glass to you."

The tension was gone. Halle stood up looking relieved. "I think it must be time for dessert."

The four chatted amiably, ate peach and angelica pie, and drank coffee until Halle announced that it was time for Junto and her to retire. Junto couldn't help but grin. Mr. Hamattan then declared that he must return to his ship. So Ana escorted him to the front door and helped him on with his coat. "Ana, that was a wonderful meal, thank you. Our hostess was right: responsibility should be taken seriously. Good night, my dear."

As she closed the door, Ana could just pick up the words of the song Mr. Hamattan was singing to himself, "And if I were young, my soul would die in the beauty of your eyes."

When Ana returned to the living room, it was empty. Halle and Junto had already made their retreat. Feeling suddenly very alone, she began to clear the dishes. Her bedroom had no appeal. Where was Zephyr when she needed him?

18

"Ana. Try to keep your head and shoulders still. Move your hips independently."

Did he mean independently from my head and shoulders or independently from each other? Maybe he meant both. Ever since my dancing had become stuck, Sirocco had taken it upon himself to tutor me. This was not something we had discussed; it had simply become inevitable. Initially, it had been wonderful to have someone serious and well versed in musical rhythms who was willing to direct me. But now I was beginning to feel unsure of where he was taking me.

I stopped.

"What's the matter?" He was sitting on the floor, drums between his knees, his shirt undone to the waist and his loose trouser legs rolled to his calves. For over an hour he'd been trying to teach me a dance employed by an oasis tribe whose women were reputedly able to bewitch anyone who watched them. But the sensuality of the movements was making me feel self-conscious.

"Maybe I'm thinking too much. This all feels so strange to me." I was hot and frustrated. I worked my neck from side to side trying to loosen the growing tightness in my back.

"It's bound to," he replied. "You cannot expect to learn to dance from the inside until you can control the outside. Your stance is too high. Try again. Bend your knees and lower your center of gravity. Flatten your soles to the ground."

It was the third time in the last ten minutes he'd told me that, but even though the position increased my stability, I repeatedly found myself reverting to the balls of my feet.

I tried again, but again I stopped after a few minutes. "I'm sorry, but I'm not sure what I'm supposed to be doing, Sirocco. This feels like some kind of fertility ritual."

"Of course it feels that way. It is fertile. You want the earth to teach you, but you are not willing to let him in." For the first time since I'd known him he sounded impatient with me. "The dance you seek demands that you spread yourself. Only when you open to the rhythm will you be able to seduce."

"Seduce? What do you mean?" My response was abrupt and filled with suspicion.

"How else do you think you will win over your tribe?" he said, brushing aside my defensiveness. "All leaders seduce their followers. Do you imagine they will put their faith in an inexperienced girl? No, of course not. But I can promise they will follow to the ends of the earth a woman who embodies all the passion they are unable to summon within themselves. As long as you are frightened by your own power you will never convince anyone to follow you."

Coming from him, the words shocked me. But I knew they contained a hard truth. The journey I'd embarked upon was not for the weak or the

halfhearted. I took in a deep breath and let it out slowly. I didn't want him to think I wasn't up to the task.

"Sit here," he said, smiling with a conciliatory warmth. He gently patted the space next to him. I sat on the floor by his side and he handed me one of his drums. "I want you to do as I do." Sirocco slowly beat out a rhythm. I did my best to mimic him. After a few minutes we were tapping in unison. He sped up and I followed. Little by little, the sound grew stronger and before long I could feel the pulse running right through me.

"Now, Ana. Consider the ground as your drum. Dance!"

I closed my eyes and tried to beat the arches of my feet into the tiles. I wanted to crush my inhibitions. The thought passed through me that if I really did let go, I'd have no control over what happened.

"Faster," he demanded. "Good! Keep going!"

My ankles were hurting.

He kept on drumming. "What you want will always be beyond the corner of your eye—let it go."

I was near exhaustion when it happened. Something changed. I had the strangest sensation that I was no longer the dancer, but the dance itself.

"Yes, yes!" he called out, still pounding relentlessly on the little drums.

My legs were rubbery, but my body kept going. I was dancing closer to him now, only a few feet away. I was turning my body inside out and he was watching me intently. His hands held the drums and the drums clutched at me.

My hem was almost touching his face, my head was thrown back, and then I looked up and saw a pigeon, black against the glass ceiling of the Carta Rosa.

My arms dropped to my side and my feet stopped moving. There was something not right. It wasn't the right place. Nor was it the right time.

I looked down at Sirocco. He was watching me placidly. The drums were silent. Gone was his fervor and, for a second, I wondered if I'd imagined the look I'd seen on his face just a few moments earlier.

"I have an appointment," I said, my heart galloping. "I must go."

He nodded silently.

Hours later, I still couldn't be sure whether he wanted to help me or was trying to mold me into a performing toy.

Zephyr gave me a last grin and swiveled back to the controls.

I watched the ground slip by, moving so much faster than I'd imagined the ground could move. I thought, It's all right, the plane's wheels are touching the earth. I'm still safe.

Then we took off. Cold air was blowing hard into my face. I told myself that this was no different from my ride in the glider at the fairground. But that was silly because this time we kept on rising, climbing away from the fields and the trees. I was no longer part of the world down there and suddenly my apprehension was replaced by wonder.

My train had arrived at the station mid-morning, a beautiful Indian summer day. Zephyr had met me and talked excitedly as we drove. "I was going to run the plane down the wharf and take her off over the seawall, but then I thought better of it. The surface is potholed and if a wheel caught she could

have been thrown into the sea or smashed against the archways. In the end we took off the wings and had her towed here to the flatlands. I've taken her up half a dozen times and she's perfect. She can twist and turn like a goshawk and she's quick as lightning."

It felt so good to be with Zephyr again, seeing his tousled hair and hearing his bubbling enthusiasm. He wasn't self-absorbed like Boreos. Zephyr's conversation may have been all about his plane but the arm he had put around my shoulder made me feel that his attention was directed toward me.

After about half an hour's drive we came to a farm. We drove over a bumpy track to a large mossbacked barn. It turned out that Zephyr had rented the temporary hangar for a few months, specifically to house the plane. He introduced me to two young men in farm overalls, Bernado and Rael, who he said had been helping him.

They wheeled out the plane and I had to admit it looked very different from the skeleton I'd seen back at the workshop the previous week. It was sleek, had been painted scarlet, and seemed much smaller against the open skyline.

When it had been pushed into position at the end of the newly mown runway, Zephyr asked, "Are you ready?"

I gulped, "I guess so."

He handed me a pair of goggles and a leather skullcap with earflaps. "Put these on," he said. "You'll need them." Then, reaching into the backseat, he produced two fur-lined leather jackets. "And you'll certainly need one of these!"

"But it's a lovely day. Won't I be too hot?" I queried.

"Up there, and at the speed we'll be traveling, you'll turn into an icicle if you don't wear it." He was not only putting his jacket on but buttoning it up.

"Okay. You're the pilot," I said, sliding my arm into the first sleeve.

"That's right. And as my official copilot you are required to do as you are told!" Zephyr pulled down his goggles, emphasizing his seriousness. He looked like a frog. I started giggling and then I realized that, since I'd already donned mine, I must look like Mrs. Frog.

The plane had two seats, one behind the other. Zephyr helped me up into the rear seat and then climbed nimbly into the front. He swiveled around, tilted his head forty-five degrees so that our goggles wouldn't collide, and kissed me. Then he gave the thumbs-up to his helpers. Rael took hold of the propeller and yanked it down violently. On his third attempt, the engine caught and the blades started spinning. My heart started to race.

And there I was, gazing down on not just the farmhouse and barn but the whole of the surrounding landscape. I was flying; I was a creature of the air. I said to myself, "I am truly blessed." Then I shouted to Zephyr, "This is what it must be like to be one of the winds." But he couldn't hear a word.

We flew south passing over rolling hills. I watched the plane's blue-gray shadow skimming the landscape. I looked west and against the ocean horizon I saw the silhouette of Serona. Zephyr had been right about the cold. I'd already turned up my collar and my hands were shoved deep into the jacket pockets. I hunched down to get farther behind Zephyr's head and shoulders. Soon we came to the edge of a dense forest and Zephyr steered the plane over the mass of trees. He dropped a little lower so that we could see more clearly.

Every now and then the noise of the plane would disturb a flock of birds and they'd erupt from the foliage.

Zephyr turned back to me and pointed down, mouthing something I couldn't catch. I followed the direction of his finger and there, wedged in amongst the upper branches of a tall oak, I saw the remains of his old dragon-fly. Then it dawned on me. We're flying over *my* forest. We're flying toward the campsite. A whole jumble of thought rushed into my mind. Is he taking me home? Surely not. What would it be like to go down, to climb out of the plane and take off my goggles and cap and have everyone see that I've returned? Would they realize immediately that I have nothing for them—that I'm not ready yet? And what would I say to make them forgive me? Who apart from Grandpa would understand my reasons for leaving?

The far side of the forest was drawing closer. I tapped hard on Zephyr's shoulder, but he ignored me. And then we were over the valley and beneath us were the caravans and my people. It was so familiar and yet so odd to see it from such an elevation. Everything looked tiny. We dropped yet lower and I could start to make out some of the figures. I searched for my parents and my grandfather but couldn't spot them. The encampment looked so tired and worn out. If I needed any additional proof that our tribe was in decline, it was there for me to see in all its melancholy.

Some of the children were waving and I was waving back. What would they all have thought if they'd known it was Ana?

Zephyr was passing me something. It was a chalkboard. On it he'd scrib-bled, "Do you want to land?"

I hastily rubbed the words off. Licked my gloved finger and wrote emphatically: "NO."

We passed close by the Windtower and I remember how tall it had always looked to me. Seen from the air, it wasn't as daunting, or even that impressive. Part of me still wanted to go down and hug every last person at the campsite, but I knew I just couldn't.

Zephyr had finished circling and, as we were passing over the campsite for the last time, I caught sight of Pax sitting on the steps of Grandpa's caravan. He was looking up as if to see what all the commotion was about. I wondered if my grandfather had gotten my letter.

Crossing back over the forest my mood was confused and I couldn't seem to break free from my internal debate. What was my real responsibility? To ease their concern about me or to wait to see if I could find the steps that would help liberate them?

Zephyr handed me the chalkboard again. On it he'd written, "Trust your first instinct." It was as if he had read my thoughts. And I felt better that he understood me. I was glad I was up in the sky with him and not down there apologizing for my actions.

A short while later, Zephyr brought the plane down in a smooth landing not far from the Whistling Pig. As he helped me out of my seat I realized I was stiff as a board from the cold. The firm ground felt quite peculiar under my feet. I was glad to return to the elements I knew, yet I couldn't wait to return to the sky.

Zephyr took my hand and led me toward the river. I squeezed his fingers, "Thank you. If it hadn't been for you I would never have known what it was like to do that."

"It was my pleasure. I want to make you happy, Ana. I want to see you smiling all the time. I know that's not possible, but I want to try."

"You do make me smile," I said. "You have a way of making me forget. Maybe not everything, but certainly most of my worries. A few moments ago, all I could think of was how guilty I felt about my responsibilities to the tribe. Now, I have to admit, all I'm thinking about is . . . when is he going to kiss me?"

He pulled me toward him and answered my question.

We walked along, following the river's twists and turns and then, stopping to shield his eyes from the sun, Zephyr asked, "What do you think that building is over there?"

Ahead of us was a tiny structure with a door but no windows. "It's probably a dovecote or a pigeon loft," I replied.

"Good," he said "I'll race you there."

We arrived together. The door opened at a push and we scampered up the rough wooden ladder that led through a square trap hole to the second floor. More than half of the straw roof had fallen in, leaving the blue sky to fill in as a ceiling. The pigeons had long since flown. Someone, possibly a traveler or another couple, had spread a thick layer of dried grass over the straw and made it into a soft bed. We needed no further encouragement. We were undoing each other's buttons as fast as we could. I pushed him backwards and fell on

top of him. He reached up, grabbed my arms, and twisted his hips, flipping me onto my side so that I was facing him. The dried grass was wonderfully soft and warm from the sun. We returned to undressing one another. When I was naked to the waist, Zephyr drew back. His expression seemed almost wistful.

His eyes stroked me tenderly and I felt no shyness. He gave an almost imperceptible sigh, and then he leaned forward and rested his forehead against my collar bone. There was a long silence.

"Are you all right?" I asked, a little concerned.

"Yes, I'm fine," he said, straightening his back. "I just wanted to take you in."

He laid his hands on my shoulders and ran his palms slowly down my chest to hips. He paused with his thumbs angled across my belly as if deciding where to travel next. My skirt had ridden up the full length of my thighs. I pulled him to me, the weight of his body on my hips and chest. My legs opened of their own will. I guided him into me and the sound that came from me was not one I recognized.

Everything was so utterly different from my experience with Boreos. That night—it seemed ages ago now—had been a game, but now I recognized that we had shared no intimacy. We had fused externally, but I had enjoyed myself from the safety of within. With Zephyr, I felt as if I had been joined—not just by his physical being but by his heart and spirit. I opened to him and for however long we made love I lost myself within him.

We lay on our backs, side by side, my head resting on his outstretched arm. In silent contentment we watched as a few small clouds passed across our ceiling.

"Thank you," he said, breaking the stillness.

"For what?" I replied.

"For helping me land safely."

I sat up enough to rest on one elbow. "So, I'm a runway am I?" I said, grinning.

"No. I mean . . . I've been up there for so long," he gestured toward the sky. With his head tilted to the sun I could see the slightest youthful growth on his chin. He was such a contradiction: one minute a loving boy who barely needed to shave, and the next a handsome, world-weary man. "I'd forgotten what it was to be flesh and blood," he said, looking back at me.

"Well, you certainly are flesh. And fine flesh at that. But as for blood . . . let me see." I rolled over and pretended to bite his shoulder. He wrestled me off, both of us laughing. And then we made love again.

We were leaving the pigeon loft when Zephyr asked, casually, "Is Boreos still sending you those notes and flowers?"

"Yes," I laughed. "But it's down to once a week."

"Why don't you tell him to stop?" Zephyr's voice had a slight edge to it.

"I've tried, but he doesn't seem very good at listening. Why? Don't tell me you're jealous."

"Of course not," he said, his eyes on the distant hillside. "I just don't want anyone bothering you."

I kissed Zephyr hard on the lips. "You needn't be concerned. Boreos is in the past. You are *now*."

"I wouldn't care to lose what I've found," he said, his arms tightening around me.

Back at the plane, Zephyr changed the subject, "Would you like to learn to fly her?"

"You mean now?" I asked, in surprise.

"No. I'll need to fit a dual control in the back, but that shouldn't be difficult. Maybe in a week or so."

"Do you really think I could?"

"Certainly. It's not that difficult."

Never had I felt as happy as I did on that return flight. I was filled with Zephyr's ease, grace, and exuberance. The plane dipped and rose, rolled gently hither and thither, and I knew that he was teaching me how to move, how to dance.

We landed back close to the farm—Zephyr's touchdown was again perfect. It was dusk and there was no one around to help wheel the plane into the barn, so the two of us pushed it on our own. I didn't want to say good-bye to him yet.

"Where do you sleep when you're up here?" I asked.

"There's an old caravan behind the barn. It's clean and I can cook there." He had a knowing smile on his face and I assumed he was reading my mind again. "Do you have to get back tonight?" he asked.

"Is there an early train into the city tomorrow? I have to be at work by eleven." I didn't want to leave the other girls short-handed.

"Yes. I'm pretty sure there's one that goes around eight."

"Then I'll stay," I said.

His response left me in no doubt that I'd made the right choice.

19

Just as Ana was coming out of the bathroom a few days later, her wet hair dripping, the doorbell clanged noisily. She decided to ignore it and was vigorously rubbing at the silky black tangle shrouding her face when the bell rang again. She smiled to herself. It was probably Zephyr forgetting his keys again. He'd left twenty minutes earlier and was supposed to be on his way to the station to catch the mid-morning train up to the farm, but it wouldn't have been the first occasion that he'd found an excuse to return home and drag her back to bed.

Grabbing her own key from the pocket of her coat hanging on the back of the door, she ran nimbly to the front window at the end of the hallway, intending to toss the key to her lover. She leaned out of the casement and saw, not Zephyr's ruffled mane but instead the smoothly combed hair of Boreos. She jumped back quickly. Thank heaven he didn't see me, she thought, her heart pounding in relief. I must look like some half-naked trollop.

As it turned out, Ana was wrong. Boreos had glanced up just as she was retreating, and he chose to take her partially robed appearance as a sign that his mission was perfectly timed.

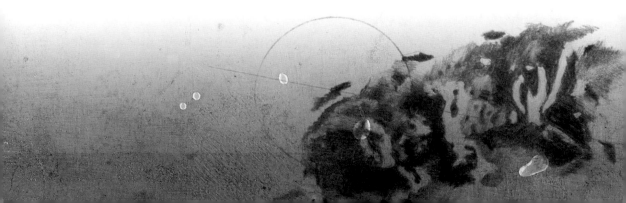

She rushed back to her room, threw on more clothes, and dragged a brush through her hair. As she passed the mirror she checked her reflection to make certain she was presentable. Coming down the stairs, she heard Boreos yank on the bell chain again.

Trying to disguise her fluster, Ana called out, "I'm coming." And then under her breath, "Please go away." But as she was opening the door, she found herself wondering why her appearance mattered to her if she simply wanted to be rid of him.

"Hello, Ana," he said, exuding his usual confidence. "I hope you don't mind my calling unannounced." In contrast to Ana's mismatched apparel, Boreos's attire showed that he had obviously taken great care with his appearance. He was wearing a gray, fashionably cut suit and his shoes were so buffed that they could have been made of amethyst. Some kind of a masculine scent drifted toward Ana.

"Boreos. To what do I owe this honor?" If her response lacked originality, at least it did not betray her inner confusion.

"I was hoping to speak with you, and as you haven't responded to my flowers and notes I thought I'd catch you before you left for the Carta Rosa."

"I suppose you should come in," she said. It didn't seem appropriate to keep him on the doorstep. "We can go through to the sitting room." She offered him a straight chair and then sat herself in another, the table between them.

He ran his hands through his hair, smiling winningly. "Ana you look more beautiful than ever . . ."

Ana cut him off. "That's nice of you, and I'm sure you mean well, but I don't need flattery. What exactly do you want to say to me?"

He sighed heavily. "I'd prepared a lovely speech. Are you sure you don't want to hear it?"

"Thank you, no. I need to finish drying my hair." In truth, she would have been more than curious to hear what he had penned for her, but she didn't want to allow him to dictate the terms of the conversation. Particularly given how vulnerable she felt without any undergarments.

"You see, there it is in a nutshell. One minute we're perfect lovers and the next you've set me adrift as if there were nothing between us."

"Boreos, I'm sorry if I hurt your feelings." Ana was certain that it was his pride, not his feelings, that had been hurt. "How can I phrase this?"

He laughed, "I hardly think you need to be delicate with me."

"All right," said Ana, gathering herself. "Our night together was, I admit, an exhilarating experience. And I wouldn't want to wipe it out. Yet we both know that that's what it was, an experience."

"I'm glad we agree on our compatibility." Boreos's capacity for interpreting everything in a way that fit his own needs was infuriating.

"We *were* suited to the moment." She put as much emphasis into the word *were* as she knew how. "But you must have known I had no intention of becoming one of your mistresses."

"Ahh!" he said, as if he had seen the light. "You really do think I was trying to buy you, don't you? I promise, on my honor, that was not my intention. I

admit I did underestimate your independence, but offering you the studio was no trap. All I wanted was to give you the opportunity to practice your art."

"Boreos, how many lovers have you had in your life?"

The question caught him by surprise. "I don't see what that has to do with . . ."

"It has everything to do with everything. I may sound pompous but I'm serious about what I'm doing. I do not intend to diminish myself by becoming your slave, like poor Sophie."

"Ignore Sophie. She's little more than a child. I brought her to the restaurant mostly to make you jealous."

Ana shook her head in disbelief at his callousness. "You are unbelievable."

"Somehow I don't imagine that was meant as a compliment." He seemed unruffled by her disapproval.

"Are you really that impervious to other people's feelings? Or is it some arrogant game you're playing—one that you think makes you irresistibly attractive?" Ana could no longer be bothered with politeness. "The truth is, I didn't want to become involved with you because you're slippery and guarded."

"I'm not guarded!" Ana thought he actually sounded put out. "I took you into the volcano, told you all about my lifelong study. What more do you want?"

She put her palms flat on the table, her fingers spread. "All right. Tell me who you really are. No more weaving around. Who is Boreos? Where do you come from? What are your parents like? What do you dream about?"

For a second he looked blank. "You mean you think I'm hiding something?" Ana slammed her hands down in exasperation. "Don't pretend you're dumb." She could hardly believe she was talking to Boreos like this. "Tell me who you

are, or leave me alone." And then she thought, This is crazy. Why am I giving him an ultimatum when I have no intention of giving him a second chance?

Boreos stood up slowly. Put his hands in his pockets and walked to the far end of the room. He examined the wallpaper as if looking for a message in the pattern. When he returned to the table the expression on his face had changed. It was as if he'd peeled back a mask.

He paused, picking his words with care. "You remember when we were strolling arm in arm, that night you stayed with me? You told me a story about your grandfather and how he'd posed you the question, 'If your caravan were on fire, what one thing would you take as you escaped?' And how you had made him laugh by answering that you would take the fire?"

"Yes." She was surprised that Boreos remembered. "For the rest of that year, Grandpa called me Firefly." The pleasant memory warmed her. She cleared her mind, "What does that have to do with who you are?"

"I am the wind that carries that flame."

"Oh, please!" Ana couldn't believe this new level of self-aggrandizement. "Don't be patronizing. If you don't want to be open with me, that's all right. Just don't expect me to believe anything you say."

Boreos's fist balled. A cloud must have crossed the sun, because the room blackened with shadow. She felt as if she were shrinking, receding down to the size of a beetle on the carpet. Boreos seemed to be towering above her. She had the sense that he was pressing down on her, but she refused to be crushed. She dug her heels hard into the ground and pushed back with all her will. She heard herself saying, "Boreos. Stop. Don't try to bully me."

"I'm sorry," he said. "Forgive me." And as rapidly as it had reared up, the moment passed and the room filled with sunshine once again.

"I'm not used to rejections. And the idea of you coupling with Zephyr is a little hard for me to take."

Ana recoiled from the poorly disguised venom in his voice. There was the sound of a key in the door. Ana stood up quickly. "I think you should be leaving," she said, wrapping her fingers around the chair so that he wouldn't see them shaking.

Halle's voice rang out cheerfully. "Ana, are you here?"

"I'm in the living room," Ana called back, extremely grateful for her friend's timely return from the market.

"If you need me, I won't be far away." Boreos sounded prophetic. He pushed his chair toward the table and walked out into the hall, nodding curtly to Halle as he went.

"What was that all about?" asked Halle.

"To be honest," replied a shivering Ana, "I'm not sure I know."

Somewhat comforted by Halle's assurance that Boreos was full of hot air, Ana went over to the restaurant to work with Sirocco on her dancing. Since she and Zephyr had become lovers she had again found herself able to trust her body's intuition, putting behind her the stuttering doubts that had crippled her sense of balance. Zephyr had helped her confidence, but it was Sirocco

who had funneled music into her. She still didn't understand Sirocco's real motives but she had decided that his tendency to try to control her was the price she had to pay for his help. How else, she asked herself, was she going to find the catalyst that would bind the cante's dark truth with the wind's freedom from constraint?

For a change, the restaurant was fairly empty during the lunch period. The relatively calm atmosphere gave Ana a chance to think again about Boreos. She admitted to herself that he had frightened her, but she convinced herself that he did not mean her real harm. It was like when she was little and her father would get exasperated by something she'd done, and he would lean right over her and his face would grow red and the veins would stick out on his forehead.

Ana spent the evening in her room, playing her flute and waiting for Zephyr's return. When finally she heard his footsteps on the stairs, she flung open the door and wrapped herself in his arms.

After they made love, they lay together exchanging the news of their respective days. "Have you fixed the new controls yet? When do you think I will get to fly?"

"Shouldn't be more than a couple of days," replied Zephyr, tracing a line with his finger from the tip of her chin downward between her breasts and to her navel. "How did your day go?"

Ana was torn. Should she tell him about Boreos or ignore the incident completely? "It was pretty quiet," she replied. "There wasn't much of a lunch crowd and this evening I sat up here serenading myself."

"What did you do this morning?" he asked, playing with a lock of her hair.

"I danced at the restaurant." But she knew her answer was only a half-truth, so she added. "We had a visitor this morning. Boreos called by."

As soon as Boreos's name was mentioned, Zephyr went rigid. After a moment, he sat up, reached for his shirt, and pulled it over his head. Leaning back against the bedroom wall with his arms folded, he spoke icily, "You let him in the house?"

"Yes, of course. I couldn't talk to him out there on the step."

"Why not?" Zephyr snapped back.

"Because," replied Ana, alarmed by the intensity of his reaction, "I wasn't properly dressed and I didn't want to freeze."

"You mean you invited him in, even though you were in your underwear?"

Ana had had a glimpse of Zephyr's jealousy before, but she hadn't seen him like this. "I wasn't in my underwear," she said, only too aware that she was speaking the exact truth. She tried to defuse Zephyr's temper. "He was only in the house a short while before Halle came back. He came to apologize."

"So you were on your own with him?" By now Zephyr was furiously stabbing first one foot then the other into his crumpled trousers.

Ana stared at him. She wanted to calm him down, but she also resented his complete lack of faith in her. Why should she have to defend herself against

his implications? "It's okay," she said. "I sent him packing. Boreos knows that I'm seeing you."

Zephyr clearly wasn't listening to her reassurances. He pulled so hard on his shoelace that it broke.

"Why are you getting upset?" Ana asked, still trying hard to sound reasonable.

"Because I'm sick of that cocky rake and his suave superciliousness and because I can't stand the thought that you slept with him!" Zephyr spat the words out.

Ana lost her patience. Why were these two men so absorbed in one another? She hadn't done anything wrong. It was insulting that Zephyr suspected that she had. He didn't own her. No one did. "I can do nothing about what happened before we came together, can I?" Her voice grew cutting. "Or do you think I should have guessed that you and I were going to have a relationship?"

Zephyr ignored her question. "And he's not the only one. Hamattan and that smarmy Sirocco are both sniffing around you like the pair of lecherous dogs they are."

Ana leapt from the bed. "How dare you speak that way of my friends?" She was only inches from his face. "Get out. Get out of my bedroom."

"My pleasure!" yelled Zephyr, smashing the door shut.

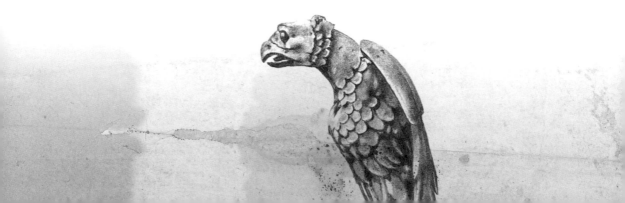

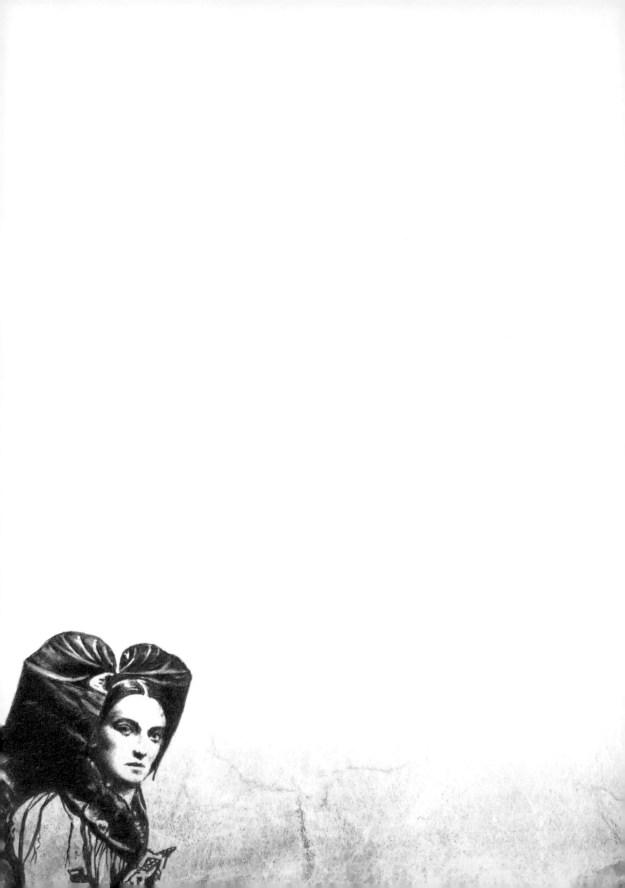

20

The door shuddered in its frame. I stared down at the bed, feeling like I'd been poisoned. How could he say those things to me? How could I have been involved with someone capable of saying them? What had happened? My head swam with the suddenness of it all. He was jealous of what? What? His rant had come out of nowhere. We had been lovers, and now we were at one another's throat? I spoke his name, but it sounded strangely foreign and distant. I was shaking. Had he cared for me? If he had, how could he lose faith so easily?

I needed to talk to Halle, to get it clear in my mind, but when I got downstairs I remembered that she and Junto had gone away for the night. I burst into tears. I wanted to talk to someone. Someone kind. Someone who did care about me. I thought of Mr. Hamattan. He was reassuring and familiar. I decided to go down to the boat and see if he was still awake.

The air felt cloying. A heavy blanket was obscuring the stars and the city's glow was reflected back off the thick underbelly of cloud. I hurried through the streets like an animal, staying close to the walls. Maybe it was silly, but I didn't want to run into Zephyr.

Heart pounding, I approached the *Mistral*. I stopped short at the exquisite flute music I heard coming from the main cabin, relief flooding through me. Here at least I felt secure. Mr. Hamattan was still up, listening to the gramophone. A light hung from the main mast and a couple of the crew were sitting cross-legged on the deck mending a large sail. I recognized one of the sailors from my voyage. I called to him, asking if Mr. Hamattan was around.

"I'll check, miss," he replied cheerfully and scampered off.

He was back in half a minute. "Yes, ma'am. Mr. Hamattan says won't you please come aboard?"

I clambered across the walkway and on to the immaculately scrubbed deck. The sailor led me to Mr. Hamattan's cabin, rapped on the door panel, and left me to wait for a response.

Mr. Hamattan opened the door. He was wearing a dark blue silk kimono over a vest and trousers. His hair was brushed back and he looked like he was close to retiring for the night.

"I'm sorry to call so late," I said, feeling awkward. He patted my hand.

"Ana, it's never too late to have a guest like you. Won't you please come in? Let me get you some tea." He rang for the steward and turned back to me, smiling warmly.

"Make yourself comfortable."

I sat down in the chair that I'd occupied a few weeks earlier, when I sailed back from seeing Felix. I wished Mr. Hamattan would massage my feet again, but it wasn't something I could ask for.

"So tell me. What's the problem? I can see you're upset."

"Is it that obvious?" I said, trying to smile and not making a very good job of it.

He nodded. "Your face is very expressive."

The words came tumbling out, about Boreos and about Zephyr and how angry they had been and how miserable I was. While I was speaking I imagined it was my grandfather I was addressing, not Mr. Hamattan. When I came to the description of Zephyr leaving my bedroom, my throat grew dry and I couldn't speak.

Mr. Hamattan said tenderly, "Come here, child."

At the camp, when I was sad I used sit on the floor, curled up, with my head resting against Grandpa's knee. I crossed the room and took up the same reassuring position. Mr. Hamattan rested his hand on my head and stroked it. After a while he began to hum quietly. I recognized it as the melody I'd heard earlier coming from his cabin. When he came to the end of the tune he bent forward. I could feel his face against the top of my head and then he breathed in. He was smelling my hair, I realized. I quickly pulled away, stood, and stretched.

I couldn't think of anything to say.

Mr. Hamattan smiled serenely, seeming not to notice my discomfort. After a pause, he said, "You know, they didn't bring us that tea. I'll go and find out what's happened to it."

While he was gone, I paced the cabin nervously. I tried to remember the tune he'd been humming. I looked over to the gramophone, but Mr. Hamattan must have put the flute record away because it wasn't sitting on the turntable.

I checked in the cupboard but it was empty. No records at all. I glanced around the room. There was no radio. The only things musical were Mr. Hamattan's instruments, most of which were hanging on the walls. An unpleasant thought began to take hold. I turned back to the gramophone. It was new and polished and didn't look like it had been used. My stomach lurched. I scanned the cabin again, more sharply, and my eye came to rest on the slim silver flute sitting on the mahogany sideboard. I picked it up and gave it a sharp shake. From its mouthpiece fell two small drops of spittle.

The ugliness of Mr. Hamattan's deception knocked the breath out of me. I dropped the flute and rushed from the cabin. He was returning from the galley, coming toward me, a teacup in each hand. Furious and humiliated, I pushed past him, spilling the tea and knocking him against the corridor wall. I couldn't speak to him. I couldn't even look at him. I was such a fool. How could I have been so gullible?

And now I was running away again. Running from the dank yellow mist that was blowing in from the sea. Running from Mr. Hamattan, even though I knew he wasn't following me.

How could he do it? How could he pretend he couldn't play the flute, when he played it far better than I could ever hope to? How could I have missed the obvious? And it was obvious. The clumsy hands, the inability to string two notes together—it was all a fake. Anyone who could construct music from a water pipe couldn't possibly be as inept as he had made himself out to be. The

mist was thickening. I was having trouble seeing where I was going, and I slowed down. Why hadn't I realized he was toying with me? Surely it wasn't an elaborate ploy to seduce me? It didn't make any sense. Of course, he had taken his clothes off at the bathhouse, but I'd believed his explanation. If he'd wanted to sleep with me, surely I would have known it. Maybe he wanted to possess me in some other way? Not like Boreos or even Zephyr, but another kind of ownership. Was it Mr. Hamattan I was enraged with or was it really Zephyr? The thought of Zephyr stabbed me harder than ever. Tonight I'd seen a Zephyr I never wanted to see again. Even if he apologized, I now knew what he was capable of. If he could look at me and see only his own anger, I could never open up to him again. I began to run once more, tears slipping down my cheeks. Soon my lungs felt like they would explode and I stopped, gasping for air. The city streets had been transformed by the heavy clouds that had descended into the mist and formed a glutinous soup. I looked around to see if I could tell where I was, but I couldn't recognize anything. The fog was encircling me, and the thoroughfares appeared to have shrunk to the size of alleyways. I was at a junction, but the signs on the buildings were too high for my eyes to penetrate the haze. I turned around and around, feeling trapped. I had no way of knowing where I was or where I should go. A muted foghorn called from my right. Did that mean the city was to my left? I listened for some other clues to my whereabouts. A dog suddenly yelped as if it had been trodden on. Then I heard muffled footsteps coming from behind me. Who else was foolish enough to be out in weather like this? Perhaps, I thought hopefully, the stranger would know where we were.

But the figure who slipped out of the fog was not a stranger—it was Sirocco. My initial relief at the sight of him turned, almost instantly, to mistrust. "What are you doing here?" I demanded. His presence could not possibly have been a coincidence. He had to have followed me.

"I was concerned about you," he said. "I understand you have had a falling-out."

"Three, to be precise. But how did you know?" I hated the idea of him creeping around, spying on me. "What is it that you want?"

He ignored my question. "It's not safe to wander around like this. There is a bad storm on its way."

I was tired of his prophetic assertions, tired of being questioned, ordered, followed, and tricked. "It seems perfectly quiet to me."

"It's a false calm," he replied. And as if on cue, an ominous rumbling came from high overhead. "There is an argument brewing."

"Between whom?" I asked sarcastically. "If it's you and me, I warn you, I've had plenty of practice today."

"You mustn't be distracted by entanglement. Come back with me to the restaurant. Everyone will have left. You can dance."

"Stop telling me what to do! I'm sick and tired of everyone trying to control me."

"You do not yet know how to let the music fill you. Let me teach you." I couldn't tell if it was the pressure in the atmosphere or Sirocco's persistence, but I felt like I was suffocating.

I threw my hands up in fury and frustration. "Can you teach me the steps to lead my people to a new home?" I found myself yelling. "Can you teach me how to focus on the brilliant point of light that trembles on the horizon? Can you teach me to forgive those who have betrayed me?" There was another roll of thunder.

"No," he said, bowing his head. "I cannot do these things."

"Then leave me alone. I don't trust any of you." A dry wind stung my eyes.

"I'm sorry. I meant you no harm," he said, looking upward as if he could see through the murk. "They're such idiots. All of them . . ."

"Who?" I asked, but he had already slipped into the blur.

The angry sounds from above were growing by the minute. Lightning crackled and the fog began to shimmer with a bronze glow. I started walking again. My thoughts were fragmenting. Time was running out, I knew. But time for what? I turned a corner and found myself in a square—on the paving stones lay a child's scuffed chalk drawing, a circle divided into quadrants, white lines dissolving into black. The fog was clinging to walls of the buildings like thick vines. In the center of the square the invisible audience was silent. I was created for a purpose and I needed to fulfill my responsibility. There were no loves and no losses. I was there to dance. I tried to ignore the turmoil above as wild squalls pulled away first the lower and then an upper level of cloud, revealing a bleak and battle-torn sky.

I was alone and I danced. I did not need to watch or listen to the raging fir-
mament. I knew that I had been forgotten in their violent sibling dispute. They
were of no concern to me. They had betrayed me and I held them in contempt.

They spat and lashed from North to South, East to West, and back again.
They rose and crashed. Great troughs of air barged from side to side across the
blackened dome and shattered against one another.

I ignored them and danced until I comprehended. Not through my mind,
but through my body. I would not, could not stop. I was free from inhibition,
flamed by the sheer force of the duende that passed through the earth into
my feet.

The battlefield spilled downward and the bellowing engulfed the city.
Tearing at its fabric, demolishing everything that was frail or delicate.
Hammering at anything that stood up to it. But I did not stop. They could not
stop me. And then the heavens split open and for an awful moment I saw the
staggering infinite depth of the universe. And there, measured against eternity,
was my paper-thin mortality, my tiny passing of years—and my soul over-
whelmed with a simple understanding.

21

Roof tiles shattered on the paving stones, windowpanes exploded, and flying shards of glass nicked at Ana's flesh. The brothers were blind to their destruction, carelessly abandoning Serona to its perdition. Ana stood at the center of the chaos and with each violent windblast she felt a fire burn more fiercely in her soul. She did not move—a steel statue in a tempest.

Then, the metal fractured. Ana's throat tore open, and from the chasm came the harshest of callings, no middle tone easy with song, but a brutal coal-black rupturing, a sound coarse enough to flay the moon. Darker and darker it went, passing below human register, down until it reached the roots of an abused people. Down farther until it awoke the deep river of sleep.

And upward it careened, through the night, piercing the heavens and stopping the winds in their tracks.

Where the storm had raved there was left only a massive silence. And in the quelled air, all sound was frozen.

Zephyr had been summoned, and he had had no power to resist her. How could this be? She was a mortal. He had not chosen to return to the earthly plane. And yet, there he was, entering the square, back in the body he had vacated. Stepping from beneath a shadowed arch, he saw Ana's slim, straight

figure shimmering against the mist. He felt a sharp twinge of longing and found himself hoping that she would forgive him his jealousy. But as he moved eagerly toward her, he saw, to his dismay, first Hamattan and then Sirocco entering the square through the walls of fog. The three men stopped and stared at one another with deep suspicion. Boreos sauntered in from the north, but the confident smile on his face was wiped clean by the sight of his brothers.

Ana waited for them. She did not fully understand how she had brought them to heel, but perhaps, she thought, that was of little importance now.

The winds crossed the square, their feet not quite touching the flagstones. By the time they reached her, each of them was possessed by a desire to make her his own.

Ana watched them glide toward her, and she held her temper in tight check. She studied each of them in turn, and not one of them could hold her gaze—caught, as they were, between arrogance and shame. Her voice, when she spoke, cut them like a blade. "I would like to know why you have been competing for me as though I were a prize to be won and displayed. Explain to me what makes the four of you believe you have the right to manipulate and play with my life, or that of any other human."

The brothers exchanged uncomfortable sidelong glances. They were not accustomed to commands from mortal mouths, but none dared oppose Ana. Their disguises had been ripped away, and it was clear to each of them that if she were to be captured, she must be placated rather than reprimanded. And looking at her, all of them badly wanted to win her.

Boreos was the first to respond. "I, for one, wasn't competing," he avowed. Although this was patently untrue, denial was always the best policy in his mind. "And I want you to know that I was truly entranced by your beauty from the first moment I saw you. My pursuit of you was sincere. I genuinely desired you."

"And when you were unable to convince me to be your mistress, you became petulant and manipulative." Ana had no intention of letting Boreos gloss over his behavior with more insipid flattery. "Was that appropriate for someone of your high standing?"

Irritation crossed his perfect face. "I confess, I was surprised that I was not able to keep you once you had shared my bed," he admitted grudgingly. "And I also confess that I was irritated that the long-winded courting methods of these three seemed to be more effective in gaining your good graces." He glared at Zephyr.

"You are assuming that courtship was the intent of all of us." Hamattan seemed anxious to put the record straight. "But I wish to tell you, Ana, that I was not trying to make love to you."

"What was that business with sniffing her hair, then?" asked Zephyr.

Hamattan blushed faintly. "Have you never smelled a young person's head? It had been so long since I'd had that pleasure. I'd forgotten how sweet and innocent that scent is."

"And the naked bathing?" Zephyr was far from convinced by Hamattan's protestations.

"I've always found prudishness rather odd, and I couldn't help teasing her when she refused to join me in the bath." Hamattan grew even more sincere. "I meant it when I apologized for causing you embarrassment. I was not trying to seduce you, Ana, but I did come to relish my paternal status and I have grown greedy in my desire to watch over you."

"For heaven's sake, Hamattan," said Zephyr sourly. "Be a man and admit you want her!"

Ana held up her hand. She had not brought them here to continue their fight. They were well able to rage at one another without her assistance. "I have asked you for the truth, yet you persist in your deceit." She was shaking her head in disbelief and disappointment.

Sirocco now spoke, "Let us play no more games, brothers. We have each tried to help this young woman in her admirable quest, but we have also tried to help ourselves. Some of us more than others. We have offended her and we are here to make amends. Is that not so?" Boreos, Hamattan, and Zephyr nodded their agreement. "In our own way, each of us wanted to have her to himself."

Boreos, who was always first to argue, was also first to crave conciliation. He coughed and said sententiously, "That is gracious of you, Sirocco. But, as important as it is that we accept our bad manners, what real harm have we done?"

"What harm, you say?" cried Ana incredulously. "Look around you. What can you see? A city battered and bruised by your mindless brawling." She

glared around the little circle. They were immortals and they must take responsibility for their actions as the winds. "Look!" she demanded again. They did not look. They knew what they had done. Shame gnawed at them as it had not done for thousands of years. Again, the brothers exchanged guilty glances and then turned back to Ana with new respect. This child was supposed to be their inferior, yet she had seen through them. Somehow this made them desire her all the more. Even Boreos, who never paid much notice to anyone, found himself under the spell of this fiery girl.

Ana continued more gently, still insistent that they take responsibility for their actions. "Can't you see that if you fail to show charity and celestial virtue toward mortals, then we will turn our backs on you? Do not be mistaken; you need us as much as we need you! Without us to tend the earthly plane, you would be mere wisps of abstraction. Who would you be if there were no humans to acknowledge your existence? If you abandon us, you cannot blame us if we abandon you." Ana looked around at their confused faces and sighed. "Rightly or wrongly, I believe you have at times genuinely cared for my kind. And I believe you cared for me. But your self-indulgence has cost us too much. It is time for you to repay those generations that you have abused or ignored down through the ages. I cannot say that I believe you to be malicious or even unscrupulous. It's just that you have not been called upon to apply yourselves to anything other than your own immediate wants and desires for many centuries. I hope that in future you will regain your understanding of humankind, and that through this understanding you will come to wear your immortality with a more befitting dignity."

They stared at her in rapt silence. Finally Zephyr spoke quietly. "Ana?"

Her face softened as she turned toward him, "Yes, Zephyr. What do you want now?"

"I believe you speak with an immortal wisdom."

"She could almost be one of us," said Boreos, as though he were conferring the greatest of compliments.

"Your vision is desolate, but it is also perceptive." Hamattan was considering the implications of her prophecy.

Sirocco smiled slowly at her, and was about to speak, when Boreos broke in, "Let us make you immortal! Then you can wed all of us."

The other three began to nod. The notion of sharing her suddenly didn't appear to bother them. "Yes," Hamattan said with satisfaction. "Yes, you would adorn the skies."

"You would dance to the music of the gods," said Sirocco, his tone resonant with pleasure.

"That is what I'm afraid of!" Ana's sarcasm went over their heads. "And I do not wish to live forever."

They stared at her. "What?" exclaimed Zephyr.

"I have no wish to be immortal," she said calmly.

Hamattan recoiled, incredulous. "You want to die?"

"I want to live with the passion that comes from embracing each moment as it passes," Ana said. "Devotion, desperation, desire—these are the essences of mortal life."

"But, Ana," Zephyr protested, "we immortals feel all of those things, too. I felt true passion—for you!"

"That's not what I mean," Ana replied. "You wanted passionately to get what you wanted. That's not the same thing. I'm talking about caring for something more than yourselves." She saw that, despite their good intent, they had not the slightest idea of what she was talking about. "Listen. I'll make you an offer. If one of you is prepared to give up your immortality and experience life as a human, to be with me and die when I die, then I will give myself to that one totally."

The winds pulled away in horror. They were floating just above her head. Love was one thing; extinction quite another. Hamattan spoke gravely, "That cannot be. If one of us left the heavens, the firmament would become unbalanced."

"Oh, surely not," Ana replied with a glimmer of a grin. "If you were to leave your post, couldn't one of the lesser winds blow in from another direction and take your place?"

The thought of being deposed by their half-brothers sent the winds into a squall. They wanted Ana, but not that much. No one should ask that they place their feet *permanently* on the ground. Even love must have its limits.

"Are you certain that none of you would like to stay?" Ana's eyes were shining.

"We could never abandon our duties," called Boreos.

"Don't worry," she laughed as she craned her neck to watch them slip upward. "Of course you couldn't accept such a proposition. But think. Think

how you felt in that half a moment when you considered your mortality. That is our fate. All our struggling and our turmoil come from knowing how short our stay is. Would it be so much to ask that the winds help, rather than hinder us?"

Had they heard her? Ana did not know, for they had spiraled far above her. They were gone now. And, at last, Ana was free.

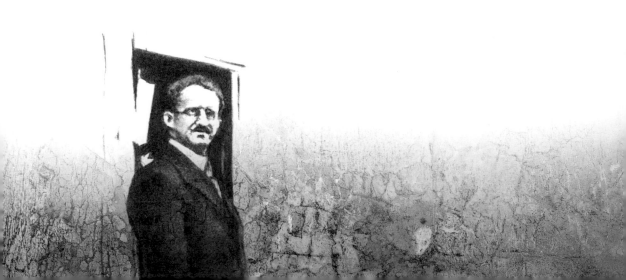

22

The heavens opened and rain began to fall—big clumsy drops that smacked noisily onto the pavement and splashed back over my shoes. The four-chambered chalk circle that I had danced over was washing away. The last vestiges of mist had dissolved and the night air suddenly smelled wonderfully refreshing. Water rushed down the gutters and the roads were cleansed. My clothes were soon drenched, but I didn't care in the slightest.

They really had gone. Maybe they had listened to me and if they had, then who knows, they might even start to take an interest in us again. They had been generous and selfish; I was relieved to see them go and I knew that before long I would miss all four of them.

I walked through the glistening streets. Even before I got back to the house, I'd already made up my mind to return to the valley. It was time for me to face my responsibilities. If there was a way I could help my people then I was obliged to do so.

I changed into dry clothes but didn't bother to go to bed. After packing my things I just sat at the kitchen table waiting for Halle to return home.

I considered telling her about the winds, but, in the end, I decided against it. Who would believe such a tale? Even Halle, with her seemingly infinite

capacity for acceptance, would probably have considered me a lunatic. I finally heard the front door swing open and her footsteps approaching the kitchen. "Halle, I must go home for a while." I began to speak as soon she came into the room. "I have a strong feeling that I'm needed there. I haven't heard back from my grandfather. I'm worried."

If she were startled, she didn't show it. "Ana, if that's your instinct then certainly you must follow it," she said. "I guessed that you'd want to make your way back fairly soon. I'll miss you, but I do understand." Her smile was warm and full of sympathy. "Do you have any idea when you'll be returning to the city?" she asked.

"I honestly don't know. I just have to go. It feels urgent." Halle could see that I was eager to set out. She put her arms around my waist and gave me a squeeze. There was something odd, not in her words, but in her face. "Halle," I said, "Halle? What is it? Why do you seem so, so . . . happy? Are you glad to be rid of me?"

"Of course not," she said promptly.

"Has something happened with Junto?" I asked. She was positively glowing.

"Ana, it's your happiness that concerns me now," she replied. "I'm certain you're doing the right thing in going back. The bedroom is yours whenever you want it." She kissed me fondly, and we walked toward the front door.

I slung the canvas bag with my clothes over my shoulder. She certainly did look radiant. "Please tell Junto I'm sorry for leaving at such short notice," I said, and, with one last look at all I was leaving, I began my journey home.

The trip was nowhere near as strenuous as I'd feared. For months the idea had filled me with nervous trepidation. But I had changed—not just from my experience in the storm but also from everything that had led up to it. I knew with a calm certainty that I was ready to face, if not conquer, whatever was before me.

First by riverboat and then on foot through the forest, I retraced my steps, my mind constantly taking note of how things looked the same yet utterly different now. I kept an eye out for Zephyr's dragonfly plane stuck in the treetop, but couldn't see it. It had probably been blown down during the storm and was resting in pieces somewhere in the thick undergrowth.

It was mid-afternoon when I came to the outskirts of the forest near the encampment. I heard the sound of an axe rhythmically striking a tree trunk. I slowed, trying to decide if I was ready to meet someone from the camp. Treading softly, I moved closer to see who it was. The young man was tall and powerfully built and when he turned his head, I caught my breath. It was Marco. I watched him for a few seconds, this man I had nearly married. He had filled out since I'd seen him last and he seemed more confident, less awkward in his movements. I could have worked my way round him, but what was the point? I was going to have to face him one way or the other.

I stepped into his line of sight. "Hello, Marco." I knew I sounded as if I were just popping back to camp after a quick errand.

He blinked, wiped the sweat from his eyes and then exclaimed, "My God, Ana, is that you?"

"Yes, I'm afraid so," I said. At least he hadn't thrown his axe at me yet.

"How are you?" He actually sounded pleased to see me.

"Me? Oh, I guess I'm fine." I paused. Better just come out with it. "Marco, I owe you apology. Well, more, really . . . much more."

"No, Ana, you don't owe me anything," Marco interrupted.

He probably wanted nothing to do with me. Who could blame him? I took a breath. "Marco, I don't even know how to begin to atone for running away in the middle of our wedding. I didn't mean to hurt . . ."

"Ana," he interrupted again, "it's all right." He leaned on his axe. "You did me a favor."

This was not the response I'd expected. "What do you mean?"

"To be honest, it was the best thing that could have happened. I wasn't keen on what we were doing either." He started to fidget with the axe's handle. "The marriage was my parents' idea. They were the ones pushing me. Not that being your husband would have been so terrible, of course, but I wasn't happy about being a pawn in their game."

"I can certainly understand that," I said, relieved that I hadn't ruined his life.

He smiled. "You certainly are looking good," he said, with obvious admiration. "You seem so much older." Then he added hastily, "In a good way, that is."

"You look none the worse for wear, either," I said, meaning it.

He brushed the compliment aside. "I'm glad you're here. We need everyone we can get for the vote. You haven't changed your mind while you were gone, have you?" He broke off abruptly "Where did you go, anyway?"

"That's a long story. I'll tell you all about it later. What vote are you talking about? And what do you mean about changing my mind?"

"You still believe the tribe should leave this place before we rot?"

I was curious about the "we," but I said, "Yes, of course. But I didn't realize that you felt that way too."

"I always did. But my parents forbade me to talk to you about it."

"What would make them do that?" It didn't make sense to me.

"Because they were frantic for the wedding to take place," he said disgustedly. "Not because of the arrangement they'd made with your parents when we were young but because they found out that if they leased the land to the Capolan, the government would subsidize the transaction."

"Why?" I asked, confused. "Why would the government pay for us to stay in the valley?"

"Because it's a lot simpler and cheaper to tie down a whole tribe than it is to oppose the people who despise us. They're under a lot of pressure to solve 'the vagabond issue.'" He scowled, "Nothing seems to change. A good percentage of the population still think we are a blight on the map."

I sighed. "Yes, I know all about that." I recalled my first day in Serona and the whispered insults that had followed me out of the shops. "So my running away ruined both our parents' plans?" It felt so strange, standing in the forest exchanging confidences with Marco as if we were long-lost friends.

"Yes and no," he replied, looking sheepish. "It's a bit more complicated than that. You see, a couple of months ago, I married Jennene."

"You married my sister!" I yelped in a very undignified manner. "I knew it!"

He flushed. "We'd always had a sort of understanding, and after you left, we didn't really have any obstructions. Once they got used to the idea, both families could see that it was to their advantage."

It made total sense. Jennene had always liked him. Tempting as it was to be indignant, I couldn't in good conscience blame either of them. "So why is there going to be a vote?"

"Because I forced it." He nudged the axe head with the toe of his boot. "When your grandfather found out that I was against staying in the valley, he encouraged me to challenge your father's right to sign the lease. As Jennene's husband, it was my prerogative."

Now I understood that "we"! Marco had become a Capolan.

He went on. "Your father was furious and said that I'd joined the tribe under false pretenses. I got angry and accused him of trying to use his daughter to gain my parents' land and of robbing the Capolan of the chance to follow their traditions. I thought I was going to have to fight him, but your grandfather stepped in and said that the dispute was best settled by an open council. Then my parents made things even more difficult by declaring that they had received another offer on the land and saying that if the Capolan didn't sign the lease quickly the tribe would have to leave by the end of the year."

"When is the vote?" I asked, dizzy from Marco's tale of intrigue. "Tonight. After the meeting, around ten o'clock." He grinned. "Your timing couldn't have been better."

"How's my grandfather?" I asked. I wanted so badly to see him.

"Not so good." Marco frowned. "But don't worry, he's getting better. I'm sure he'd berate me if he knew I'd stood here chatting, instead of taking you straight to him."

"That sounds like Grandpa," I said, but I couldn't hide my anxiety. Suddenly, I wanted to see him right away. "Marco, I don't want anyone else to know I'm here until I've spoken with Grandpa. Can I borrow your coat?"

"Certainly," he said, retrieving it from a nearby branch. "Turn the collar up, and I'll make sure the coast is clear."

Marco led me around the outside of the caravans. On the way, he murmured, "It's just as well I didn't end up as your husband."

"Why is that?"

"Because," he replied, "I'm a terrible dancer."

We both laughed.

When we got to Grandpa's wagon, Marco said, "Your grandfather gets tired easily, mostly because he won't do as he's told and insists on wearing himself out." I could hear the affection in his voice. I was glad Grandpa had someone else who was fond of him.

After Marco left, I tapped on Grandpa's door. "Who is it?" the old man's voice boomed.

I turned the handle and went inside the familiar caravan. Grandfather was sitting in his high-backed armchair, straight as ever. But his left foot was copiously bandaged and propped up on a stool. "Grandpa," I said over the lump in my throat.

His face lit up. "Windflower!" He stretched out his arms toward me and I flew to him. He tried to get himself into a position where he could lever himself up, but I didn't give him a chance. I dropped down and hugged him for all I was worth.

"Ah. I knew you'd come. I knew you would," he said.

We talked and talked. I asked him why he hadn't answered my letter. He had, he insisted, but the post was in its usual disarray and his response had been returned to him. "Who knows why? Here's the envelope," he said, reaching across to the table. "You can read it later if you want to catch up on all the old news."

"So what happened to your foot?" I pointed to the bandage. "Did you finally fall off the roof?"

"Nothing so dramatic. I simply woke up one morning with the damn gout."

"Gout, Grandpa?" I laughed. "Isn't that what royalty get when they've been drinking too much malmsey?"

"I have never so much as touched a drop in my life," replied Grandpa with dignity. "Trouble is, when it comes to tonight's vote, I'm hardly in a position to advocate a long march! You do know about the open council, don't you?"

I told Grandpa how I'd met Marco in the forest and about our conversation there. "But I still don't understand exactly how the vote will work."

"Almost all the tribe has agreed to abide by the will of the majority," he explained. "Both sides—those who wish to stay here permanently and those of us who believe we must return to our nomadic ways—will have their say. After that, we'll put it to the count."

"Do you think everyone will abide by the decision?"

He shrugged. "Not everyone. There are a few who will go or stay regardless of what is decided, but most will follow the vote. At present we will almost certainly lose."

I took his hand. "Is there anything I can do?"

He shook his head, as if my question were foolish. "Of course there is. You are the only one who can sway the whole tribe. Felix is here and—"

"Felix is here?" I cut in.

"Yes. He will bring some people around, but it won't be enough. However, if you dance the cante jondo, then they will be moved. You will show them the way forward and the vote will be rendered meaningless." He leaned forward, his eyes brilliant. "Only you can unite the clan, Ana."

I felt a shiver run through me. "Grandpa, I have tried to make myself open but I still don't know if I am capable."

"Windflower, I can see it in you more profoundly than ever. You must attempt it for all of us. Please."

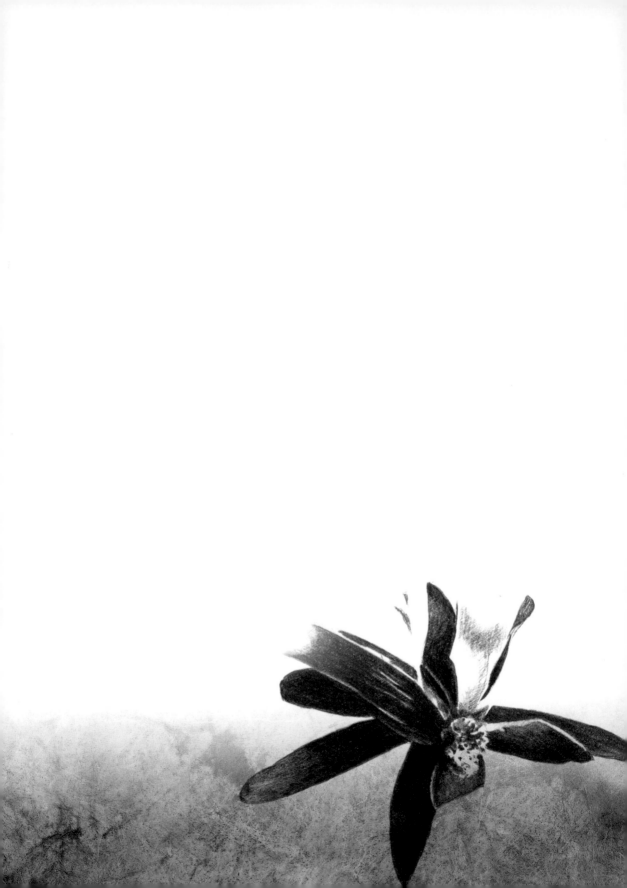

23

Ana continued to talk with her grandfather until dusk. Then she slipped out of his caravan and started to wind her way up the hill toward the old Windtower. It seemed apt that she gather her thoughts at the place where her story had begun.

Was Grandpa right? Could she show them the way? Certainly she had felt something of enormous power pass through her in the square. But would that magnetic spirit come to her again? Could she summon it? If she were the one who was able to dance the tribe's cante, then their journey would be her responsibility. Did she want that burden? The Capolan had had many hard times in their history. What if she led them again to a place of darkness and misery? Could she live with that? And what if she tried and failed? How idiotic she would look and how disappointed her grandfather would be in her!

Though she hadn't returned to the tower intending to call upon the winds, Ana found herself addressing them once again. The self-consciousness that had plagued her the last time had entirely disappeared. "What do I do?" she asked the sky.

"Don't bother. They're too alarmed by you to come back down and answer." The voice was familiar.

Ana turned sharply to see a figure dressed in an iridescent blue-green gown of kingfisher feathers. "Halle! What are you doing here?" Ana asked in surprise. But even as she spoke, she could see that this exquisite glowing creature was not the Halle she'd known.

"I've come to thank you on their behalf."

Ana's mind flew one way and then the other. Pieces of the puzzle dropped suddenly into place. Halle standing outside the Carta Rosa with a glass of iced tea. Halle and her lodger, Zephyr. Halle who seemed to understand everything. Ana knew in a blinding moment that she had been deceived not only by the winds but by their sister, Halcyon.

Right from the start, Halle had orchestrated the events. Ana could see that now. Her friend had encouraged and cajoled her through her encounters with the men. She had led them all down a path of her own choosing. It was not possible, and yet Halle was the celestial Halcyon.

"I see that it has become clear to you," Halcyon said, her voice soft and gracious.

Yes, it was clear. "Halcyon, alone of all immortals, can coax the winds to do her bidding," recited Ana.

"Apart from you, of course." Halcyon smiled.

"I don't think they would call it 'coaxing.' But I suppose you could say they did my bidding, in some form, at least." She gazed at the transformed Halle. "What was your purpose in all this?" she asked.

Ana knew she had been manipulated but somehow it didn't matter, maybe because she instinctively trusted Halcyon's wisdom.

"What do you imagine that purpose to be?"

Ana stopped to think. "I'm not sure. I suppose you were concerned about us."

"Yes. I am. And my brothers needed to remember the implications of mortality, in order to respect their own gift of eternity."

Ana remembered the way she had scolded the winds. It was a bit frightening, standing there under the Windtower, to think of how disrespectfully she'd spoken to the guardians of her ancestors.

"Oh, don't give it another thought, Ana," Halcyon said, reading her mind. "They deserved it. Long ago, they had an interest in the affairs of man. Sometimes they would even mingle and take their pleasures among the mortals. But they have grown detached of late, even selfish. And when I attempted to question their growing self-absorption, my siblings would merely remind me of their immortality and tell me that I was wasting my energy on small and insignificant matters. They had forgotten how deeply entwined are the fates of gods and humans.

"It seemed to me that, if we did not pay attention to our earthly charges, we could not expect them to respect the heavens. If we continued to ignore humankind, then they would forget us. And one day, in their innocence, they might accidentally burn a hole in the sky that would suck us all into the vacuum." Halcyon's brow furrowed.

"The equilibrium between the winds and the spirits that move within the earth's core must be held in balance by the tribes of the soil. Knowing that, I

watched for a long time, passing many individuals over. I was searching for someone with a clear mind and a tenacious spirit." She took Ana's hand. "Then I found you. Your beauty was bound to entice them. And when I saw how pure your heart was, I knew you were perfect."

Ana blushed, a little daunted by Halcyon's compliment. "Thank you."

"Are you angry with me for choosing you?" Halcyon's voice was growing even huskier and more mellow. "After all, I used you as much as they did."

Ana considered her feelings. No. She wasn't angry. "I may have been deceived. But I honor your reasons. And anyway, I used them a bit, too." She looked up quickly. "I learned a great deal from your brothers."

The goddess smiled. "And that is why they eventually had to listen to you. Ana, I can't begin to tell you how much pleasure I've had, watching them grow exasperated. Stumbling over each other in their attempts to bend you to their will." She sighed with delight. "I hope this was all worth it for you too, my dear. For all their faults, they have much to offer a woman, do they not?"

"Yes, I suppose they do," Ana said. "Even if they are pigheaded and arrogant!" She caught herself and asked, "Is it all right, my saying that about your brothers?"

"Of course it is!" Halcyon leaned forward and kissed Ana's cheek. "We're old friends. We always will be."

"What will you do now?" I asked her. "Will you go back and be with your brothers or will you stay here?"

"Both," she replied.

Ana looked at her questioningly.

"Immortality alleviates the problem of existing in only one place at one time. And, besides, Junto needs a little more encouragement!"

Halcyon gazed down into the placid valley. "So, my dear Ana. What shall we do about this evening?"

Traditionally an open council was held in a circle of torches. Everyone was there, apart from Ana. Marco and Felix stood next to Ana's grandfather, whose sense of pride was deeply offended by the folding chair he was obliged to sit in. There was almost no moon and the faces of the Capolan came and went in the flickering of the braziers.

First to address the crowd was the group in favor of staying in the valley. There were five speakers, the last of whom was Ana's father. He looked a little grayer than he had when she had run away, and even though she wouldn't have agreed with his words she would have felt a twinge of remorse that she had caused him sadness. He spoke of the years of struggle, persecution, and uncertainty. He stressed how lucky the clan was to have "our home." And he ended by exhorting everyone to vote in favor of becoming "the village of Capolan." He was no orator, but his fears were those of the people and he knew exactly how to appeal to the undecided amongst the throng.

Because of his status as a council elder, Grandpa could not speak for those who believed the tribe should move on. Instead, it was Marco who made the plea for leaving. Just by looking at him, everyone could see that he had changed since he had become a part of the tribe. Being married to Jennene

had been good for him. But he still appeared callow, and although his speech was clearer and more articulate than Ana's father's, he was only partially convincing. And that meant he was unable to soothe the doubts that Ana's father had inflamed.

Returning to his position in the outer circle, Marco hissed in Grandfather's ear, "Where is she?"

"She is coming," the old man assured him. He knew Ana wouldn't desert them.

Felix stepped forward. He took his time, a master of crowds. When he spoke, his voice was low, authoritative, and resonant. "I am not a Capolan. But many of you know me to be your friend. The council has been kind enough to allow me to speak to you briefly. And I will be brief. I agree that it would be foolish to set out into this dangerous and confusing world with no one to lead you. What would be the point of wandering aimlessly when you could settle here in this safe place? But," he said as he looked with compassion at the troubled expressions in the crowd, "is fear a reason to turn away from your history and your dignity? Mark my words, if you remain here you will lose yourself in a far harsher way than you will if you take to the road and follow the example of your ancestors." The people shifted nervously. "It has been said that the tribe has lost its power to chart a course. That there is no one to act as your pilot. No one to divine the path. I wish to refute that." He paused, and as if on cue a wind blew in from the north. "There is someone here who has her feet buried deep in the earth, who has been touched by the grace of the heavens." A second wind came sweeping from the south. Felix raised his

voice. "Forget argument, forget trying to decide your fate when you can never have enough information to rid yourselves of doubt." From the east and the west came two more gusts. "I ask simply that you watch and allow the instinct that dwells far inside you to speak its own truth."

The four winds met head-on at the center of the circle of torches. They twisted around one another in a funnel of frantic air and out of their vortex came Ana, spinning so quickly that her toes hardly touched the earth. In the flickering light of the braziers, she looked nothing less than a golden daemon, and the assembly fell silent at the sight. The coins shimmering on her head-dress, the fiery eruption of her rippling skirt, her swirling mane of hair. She bewitched them. They could not take their eyes from her. They craned forward, wanting more. And with her arms lifted like wings, Ana raised her face to the stars and called out. Her voice sounded through the chasm she had opened during the storm in Serona. And the clan took the sound into their hearts and responded with their own raw note of uncompromising approval.

Ana danced for her people. She could feel the magnetic pull far below her, impelling her body to follow its gyre. Guiding her. Guiding all of them. Through half-closed eyes, she saw, and she began to trace the line of navigation that was leading from her feet, across the circle and beyond, into the forest.

Windflower paintings and drawings by Nick Bantock,
massaged in Photoshop by Jacqueline Verkley.

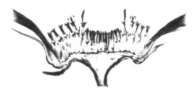

Also by Nick Bantock:

Griffin & Sabine
Sabine's Notebook
The Golden Mean
The Gryphon
Alexandria
The Morning Star